PETER GOURFAIN
Clay, Wood, Bronze, and Works on Paper

Russell Panczenko

Essay by Lucy R. Lippard

Elvehjem Museum of Art
University of Wisconsin–Madison
2002

ISBN 0–932900–79–8

This book is published
on the occasion of the exhibition
Peter Gourfain:
Clay, Wood, Bronze, and Works on Paper
at the Elvehjem Museum of Art
University of Wisconsin–Madison
January 26–March 17, 2002
Russell Panczenko, exhibition organizer and curator

Published in the United States by the Elvehjem Museum
of Art, University of Wisconsin–Madison, 800 University
Avenue, Madison, WI 53706–1479

Cover: Peter Gourfain (American, b. 1934)
Roundabout, 1974–1981, yellow pine, terracotta
H. 108, Diam 264 in. Courtesy of the artist

TABLE OF CONTENTS

FOREWORD

Peter Gourfain's work is not well known beyond the northeastern United States. In part this is due to a radical shift in style and purpose between his early and current work. During the 1960s, Peter was a well-recognized exponent of New York minimalism. Since the early seventies, however, he has depicted a wide array of literary, social, and environmental subjects in a dramatic, often humorous, figurative style. Few people are acquainted with both these aspects of his work, and those who are find them difficult to reconcile. He went from being an active insider of the New York art scene to setting his own individual artistic course. Also problematic from the perspective of modern art criticism is the question of whether Peter's three-dimensional work from the early seventies onward is to be categorized as sculpture or as craft. Although more recently, whenever possible, he has been rendering his pieces in bronze, much of his work is modeled in terracotta or carved in wood, media that have not been readily embraced by twentieth-century modernism. And, in fact, reviews of his work have appeared as often in magazines such as *American Ceramics* and *Craft Horizons* as they have in *Art News* or *Art in America*. Finally, the size and weight of much of Peter's work has discouraged its inclusion in exhibitions at a distance from the New York area. The fragile terracotta pots and reliefs easily weigh three to five hundred pounds, while works such as *Roundabout* and *Fate of the Earth Doors*, two of his most important pieces, are not only very large and heavy but also quite complex to assemble and install.

The exhibition *Peter Gourfain: Clay, Wood, Bronze, and Works on Paper* is intended to introduce this artist's work to Madison, Wisconsin and to the Midwest. If Madison were ever to designate an artist laureate officially, Peter Gourfain would probably be that person. Madison is a community of strong individualism; Peter Gourfain is certainly an individualist in his life style as well as his art. Tolerance, concern about social justice, destruction of the environ-

ment, urban sprawl, and the annihilation of native peoples, disdain for corporate culture and appreciation of manual labor are some of the key issues and values that, since the early 1970s, Gourfain's art embodies. These same ideas also comprise the progressive and liberal character for which this city is and has always been renowned. For Peter, just as for the community of Madison, the intellectual chess game of minimalism was just not enough. In 1989, the Elvehjem acquired its first piece by Gourfain, the carved wooden yoke dedicated to the memory of Michael Stewart, a young, relatively unknown artist who was killed in an incident with the authorities in the late 1980s. The sculpture elicited a strong public response and gave rise over the years to requests for more of Gourfain's work. The Elvehjem exhibition responded to those requests and provided the opportunity to photograph the complex installation pieces in detail so they could be visually documented in the present catalogue.

Peter Gourfain is an immensely private man. However, although his subject matter comes from various sources—literature, current events, and personal experiences, it is all filtered through his thoughts about the world he inhabits. Language fascinates him, and he is voracious reader. The writings of James Joyce, a favorite author, are the source of numerous images. Palindromes and onomatopoeia, and even Latin phrases abound, painted or carved on his work or used as titles. Deeper personal reactions to events or comments also appear in the works, but their meaning is often veiled by a use of an alphabet of the artist's personal invention. Charged with meaning, these undecipherable phrases appear to the viewer as purely visual values. Although Peter's work is narrative, the narrative is deliberately nonlinear. Individual scenes do not follow in sequence; each one stands on its own merits, the common bond between them being the artist himself.

The range of media that Peter successfully employs is impressive. He is equally at home model-

ing in clay, carving wood, painting or drawing on paper, canvas, or ceramic forms, as well as making prints. Least known to the public are his drawings, since he draws mostly in his notebooks. Although he considers these highly private, we were fortunate to be able to include a selection of them in the present exhibition. The notebooks, which span his entire career, contain a rich array of courtroom drawings, cartoons, textile designs, pattern studies, self-portraits, and wonderful graphic renditions of personal family, friends, neighbors, and local scenes. His public graphic style is represented by powerful drawings on the large terracotta pots of the late seventies and the early eighties and by his prints, which date from the seventies to the present. The latter have never been presented in a museum display nor published in an exhibition catalogue. In the early seventies, carving began his transformation of his minimalist work into vehicles for narrative. However, early experience with the toxicity of white pine encouraged modeling in terracotta. *Roundabout*, the earliest of his works in this exhibition, was originally intended as a minimalist sculpture but ultimately became the harbinger of his current style. He still carves in wood although he is careful about his selection of wood. Also, it should be noted that he only uses recycled wood in the form of old tools such as planes, blocks, levels, clamps, toolboxes, yokes, dollies, etc. He is consciously part of the continuous world he lives in rather than seeing himself as outside or above it. His recent clay works are often transformed into bronze but they never lose the original earthy, hand-modeled quality that has always been his trademark. When asked about his work, he speaks mostly about its contents. However, evident throughout is a natural inherent talent for design and composition that has been honed by years of practice.

Many individuals and organizations helped to make the present exhibition and publication possible. On behalf of the museum I wish particularly to thank those who lent works from their collections for the exhibition: Max and Beth Callahan, Margot and Leonard Gordon, Stephen and Pamela Hootkin, Martin Melzer, Betsy Nathan, Nina and Steve Schroeder, Richard and Monica Segal, Judy and Martin Schwartz, and the Charles A. Wustum Museum of Fine Arts in Racine, Wisconsin. I also want to thank those individuals and organizations who so generously provided the necessary financial support: the University of Wisconsin–Madison's Anonymous and Hilldale Funds, the Dane County Cultural Affairs Commission, with additional funds from the Madison Community Foundation and the Overture Foundation, and Stephen and Pamela Hootkin. Among the museum staff who were instrumental in the success of this exhibition I wish particularly to acknowledge associate registrar Jennifer Stofflet for efficiently arranging crating and shipping; exhibition designer Jerl Richmond and preparator Steve Johanowicz for the outstanding and complex installation; development specialist Kathy Paul for finding the necessary funding; and editor Patricia Powell for guiding the catalogue from idea to book. Kudos to Earl Madden of UW–Madison Communications for his admirable catalogue design.

Two other individuals merit special mention, Lucy Lippard who interrupted her current intellectual pursuits to contribute an excellent essay to the present publication and Patricia Hamilton whose exhibition first introduced me to Peter Gourfain's work in New York City so many years ago and who so graciously shared information from her files so many years later.

Finally, it has been a great pleasure to work with Peter Gourfain and to get to know him and his art in the course of organizing this exhibition. Peter, thank you for your openness and patience as we interrupted your daily schedule, tore your studio apart and probed into some of your most private thoughts. You bore it all graciously and stoically, for which I and the many visitors to our exhibition are immensely grateful.

Russell Panczenko, Director
Elvehjem Museum of Art

Interview with Peter Gourfain
RUSSELL PANCZENKO

RP: Four or five years after you came to New York City, your work became abstract and later minimal in style. Early in the 1970s, figuration reentered your work in a major way and remains there to the present day. None of your minimalist work is in this exhibition. However, Roundabout, the earliest of your sculptures in this exhibition, can be said to represent your transition from minimalism to figuration. Would you comment on that?

PG: Originally, I didn't intend *Roundabout* (cat. no. 4) to be carved or to have figurative work on it. There was an earlier piece; a smaller roundabout that turned on a bearing in the center and had no figures or narrative on it. So when I was in the process of making this one—from the model stage to construction—I wasn't really thinking of putting any figuration on it. But I'd been keeping sketchbooks of cartoons during the years while making abstract work, and I had been a figurative painter before. So, I guess, the earlier stuff—maybe it's roots, training at the Art School of the Art Institute of Chicago—started to come back. Also, in the 1950s, I'd been looking at Romanesque carvings in books. Somehow, I got hold of one of those books again in the1970s. It was like looking at comic books in three dimensions. And early Christian stuff has always moved me. The first idea was to carve the Last Supper with all thirteen figures on one of the columns of *Roundabout*. From there it took off—you know, like writers always say—the story takes over. I spent the next eight years struggling with this piece, eventually for health reasons switching from carving the wood to putting clay reliefs into hollowed-out columns.

RP: We are fortunate to have four of your paintings in this exhibition, which were done in 1977. Are they substantially different from the paintings you did when you were a student?

PG: Very different. That was many, many years before, and it was student work. My student work has nothing at all to do with the work in this exhibition, visually or in terms of its content.

RP: The content of these four paintings is complex and loaded with detail, where does it come from?

PG: The imagery of *Shattering glass and toppling masonry …* (cat. no. 6) comes from the Nighttown episode in *Ulysses*, by James Joyce. The words are quite beautiful, and powerful too: "Shattering glass and toppling masonry, I hear the ruin of all space." Something like that. It's a beautiful metaphor. I read practically nothing but Joyce for years, and I really love *Ulysses*. I use a lot of the stuff that I found in Joyce in my work. Here for instance, I read somewhere about how the Russian artist Tatlin slept in a bed with chickens nesting at the foot. That's the sleeping figure at the bottom of this painting, but the chickens have become crow-like. There's a lot going on. I can't give you specifics, nor do I feel it's necessary. Some of this is dream stuff; some of it emotional stuff. It's dramatic, like in many works of art. In another painting (cat. no. 9), the title *Dr. Swift Says: "One Man in Armor Will Beat Ten Men in Their Shirts"* is a line from Jonathan Swift. The painting is divided up into three vertical bands, and there are images from cartoons I did in the sixties and seventies. Here's (cat. no. 5) the song, *Brékkek Kékkek Kékkek Kékkek! Kóax Kóax Kóax! Ualu Ualu*

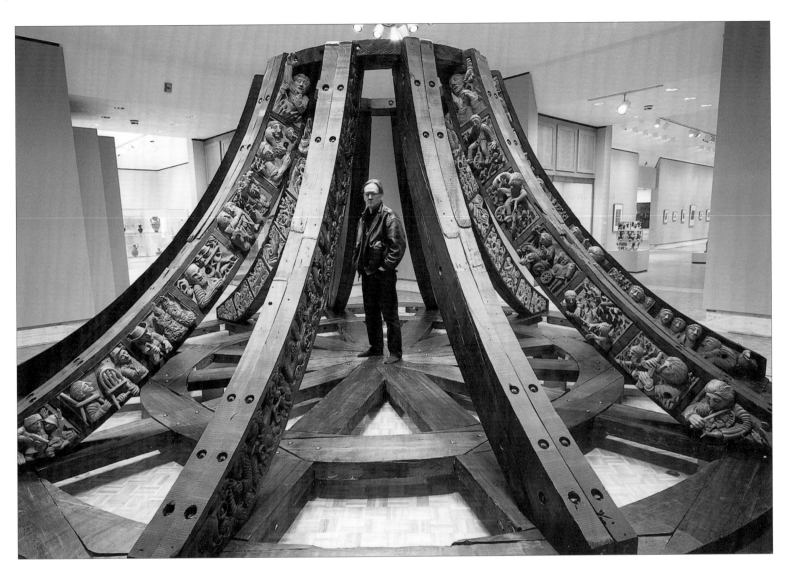

Ualu! Quaouah! That's the sound that the frogs make in *Aristophanes*. I got it out of Joyce's *Finnegans Wake*. Who the hell this giant figure with the wheel is, I don't know. Maybe he's God, maybe the devil, Zeus, or Wotan, anything that's up there in the sky that's powerful ... maybe it's fate all these little figures falling into the flaming abyss, Hades, hell, or the afterlife.

RP: Your subject matter has a wonderful range of references: literary, religious, current affairs. And throughout you intersperse a lighter note: animals, even unrelated playful episodes.

PG: It's all the stuff that occurs to you in a day, or a week, or a year, what has remained indelible from day to day. My daughter was learning how to ride a unicycle at one time—that's an incredible image—so there are a couple of unicyclists on *Roundabout*. Or you see a story in the newspaper that is very moving. There was one story (I'll make it short). Maureen, a friend of mine, went to Mexico. She had a friend who had a friend who was making a movie about a woman from Argentina. At that time, I was just beginning to do ceramics. There was a story in the *Washington Post* about this woman; it was pure

7

coincidence that a clipping of it was mailed to me. This person lost two daughters to the dictatorship down there. So I did an image of when she went looking for her kids. She was told to go to the police station in a particular city, where she found the hands of her daughter in a jar of formaldehyde, with her daughter's name on the label. That's like something out of an unbelievable movie or out the martyrdom of the saints, but it was true. So I did something about that. There are a lot of similar references to current events throughout the work, references to things that are going on in the world. A friend of mine said, "You've gone through some personal stuff recently, why don't you put that in your work?" A lot of the work that is made now seems to be exclusively personal. I've very rarely done work that's purely personal but it all comes from the inside ... the inside and the outside are sort of in balance. They have a good relationship.

RP: Then what we are seeing is not so much your inner vision but what you want others to see?

PG: Well for instance, I saw a movie last night. It was extremely depressing and psychologically upsetting. It seemed to me that perhaps the director was trying to express the tenor of the time we live in: the confusion, the violence, and the psychological malaise. I didn't see the end. I had to leave. It was depressing and sapped you of energy. It didn't give you anything back. It took from you. It didn't enable you to face what's out there. Some people have characterized what I do as grotesque. I don't think it's grotesque. They've said that there's a lot of violence. There is some violence but then there is violence in practically every aspect of human existence. It's a contest: life may be an expression of opposing forces that are always engaged. One of the last pieces I've made was about presidential election night. My daughter and I were watching TV. When Florida switched from Gore to Bush, she leaped up and said, "That's where they are going to steal it!"

And that's where they did steal it. Later in a ceramics course I teach at the Greenwich House pottery in New York, I asked the students if they'd be interested in doing a class project like drums or bells. A few of the students and I did drums. I made a drum, which is in this show, with four reliefs that depict how they stole the election (cat. no. 83). These are overpowering events. Some people feel they don't belong in contemporary artwork, but I don't agree. I think they are exciting. Whether they are good or bad, whatever is going on is grist for the mill, material for work.

RP: A number of your titles, such as for example the Last Supper, connote religious themes. Are you indeed making specific religious references or do you interpret the subject in a different way?

PG: Both. A group of people sitting down at a table eating has always interested me as a theme because it's a concentrated social event in a small space. There are lots of different things going on. There's eating, there's talking, there's the rhythm of the people, the figures, there's the texture and the color of the food itself, the glasses, the plates, the utensils. Maybe it comes from the biblical Last Supper; maybe it comes from van Gogh's *Potato Eaters*. I began using imagery related to the Christian epic because of my interest in Romanesque art. I was moved by the narrative power of Romanesque work, by its folk quality, its expressive and theatrical intensity. In Romanesque work you also get a lot of non-religious stuff. Romanesque figures are quite different from those of the Renaissance. They're not realistic. They're not portraits; they're symbols, actors in plays wearing masks, and that's what I'm after, something that has lots of shadows, lots of highlights, and lots of mystery. In the three large eating scenes, the one carved on *Roundabout* (cat. no. 4, detail), the vertical terracotta (cat. no. 28), and the one using the chairs (cat. no. 48), all of which are in relief, it's the same feeling; the intention is to get this concentrat-

ed social act, you know, eating around the table. It's powerful imagery to me. But it's also the Last Supper. Most of the Last Suppers that I've seen in religious art, the ones that the general public knows best like Leonardo's work or Tintoretto's, are of less interest to me than the primitive and the early Christian stuff.

RP: The supper theme lends itself to the inclusion of numerous chairs. Chairs appear throughout your work starting as early as in Roundabout *and continuing even in a series of more recent prints. Why chairs?*

PG: I came across this medieval drawing in a book. It looks like the top of the earth. And there, three guys are shoveling chairs, a chaos of tumbling chairs. They've got wooden shovels, and they're shoveling chairs all over the place. That may be the original inspiration for chairs as a motif. It's a pictorial device in the linoleum cut (cat. no. 58) as well as in the clay piece (cat. no. 48) of what you might call the lunatic's Last Supper or, if you want, the artist's Last Supper you get the rhythm of the rungs of the chairs. It's a pictorial device that when used with figures, enables you to leave out the body. Maybe the chairs are a substitute for the human body in some of these works where there is just a head coming out of the seat of the chair.

RP: Awa to Ealdre *(cat. no. 61) is an unusual title. What is the piece about?*

PG: I found the block on Atlantic Avenue, Brooklyn in a shop associated with a church that sells old stuff. They had three of them. The interesting thing about this block is that it has *lignum vitae* wheels and *lignum vitae* is the hardest wood on the planet. They used it for the wheels because it wore out very slowly. The wheels and the block had enough surfaces to put a lot of imagery on them. The quote is from the Anglo-Saxon poem *The*

Seafarer, which Pound translated in 1912, and has something to do with the idea that what you leave behind speaks eloquently to coming generations. In an image on one side of the block a figure is carving a bird out of clay or wood; on the other side there are images of John F. Kennedy and Martin Luther King holding their respective symbols. For me they are two of the four modern evangelists. As the early Christian evangelists had their animal symbols, Martin has the symbol of the bird and John has the symbol of the stag.

RP: Who are the other two modern evangelists?

PG: Malcolm X and Robert Kennedy. In Joyce's *Finnegans Wake* there is a character called Mamalujo; the name is made up of the first two letters of the four evangelists Mathew, Mark, Luke, and John. If you do the same thing with the names of the four modern evangelists you get Mamarojo, which is Martin, Malcolm, Robert, and John. I thought: "What a coincidence, and an eloquent coincidence besides."

RP: What are their animal symbols and did you assign them?

PG: I assigned them, yes. The lion for Malcolm, the stag for John, the sea gull for Martin, and the otter for Robert.
 This large yoke (cat. no. 53) deals with the Mamarojo theme. It's got lots of poetry—a poem by Herman Melville, about the assassination of Abraham Lincoln; a poem by C. Day Lewis that's about the death of somebody, I don't know whom; it's the last quatrain. On this side of the yoke, the Latin *unde negant redire* means, "from where there is no return." There is the palindrome, "Satan oscillate my metallic sonatas." On this piece you've also got the depiction in four scenes, as in the linoleum cut over there entitled *Satan Oscillate My Metallic Sonatas* (cat. no. 46), there is a depiction of the

assassination of one of the four modern evangelists. Then there is the hand with stigmata. Bullets and coins are falling out of the stigmata. A lot of other stuff appears on this yoke.

RP: That's a very complex compilation of material. On the urns you made in 1980 in Ohio, you organized the narrative in horizontal registers.

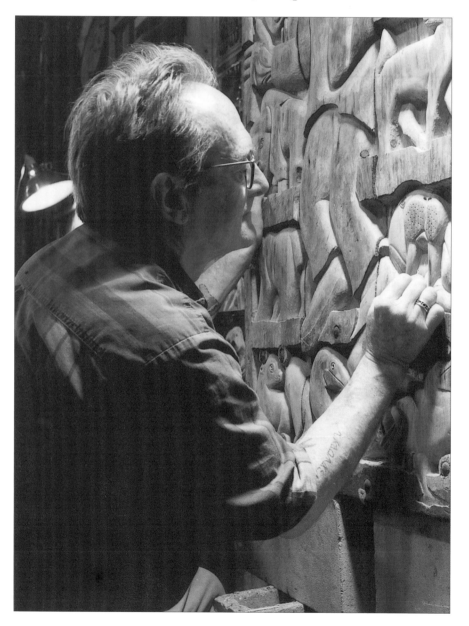

PG: It's easy to control a cylindrical space such as on the urns if you divide it vertically and horizontally. It's not very complicated; it's a way of controlling the space. There are eight figures on the bottom register. There are four handles; there are four figures in between the handles. The tug-o-war that you see is the *leit motif* on all ten of the urns in the Ohio series. I also used as a kind of signature on the urns the Serpent Mound that is in southern Ohio near Chillicothe. I used it because I went to see it while I was there and as a sign of where the urns were done. One of the people who occasionally assisted me crushed his little finger under Pot #7, so I put his portrait and an image of his crushed finger on that pot. (His finger healed miraculously.)

These two pieces, *Carmen y Roderigo* (cat. no. 32) and *Welcome Home* (cat. no. 31) have related themes. Both are about the young Chileans who went back to Chile from the United States after the Allende government was overthrown in 1973. They went back and were set afire by the cops. He died, she lived, very disfigured, and it's a kind of use of martyrdom in the same way early Christian art uses the martyrdom of the saints.

RP: That's quite an iconographic jump from the literary and biblical images we discussed earlier to these stark realities of current events.

PG: Well, I read newspapers; I read books. You get inspiration from your own life, from the lives of others, from art, from wherever you find it. All artists do the same thing. They reflect the stimuli in the world, and I'm doing what other artists do—getting it wherever I can find it.

RP: The carved depiction of Carmen and Roderigo on the dolly includes images of birds, shells, and penguins on the bottom together with their martyrdom. Do these lighter motifs relate directly to the story or are they there to fill visual space?

PG: Penguins and blue-footed boobies are native to the Southern Hemisphere, specifically the Galapagos Islands off Chile. There is a large population of boobies on those islands off Chile. I put birds in a lot of my work because birds are a symbol of the spirit in a way. They say the flight of a bird, the image of a bird has a lot of significance to every people on earth. That's why I use birds.

RP: *Unlike most artists who carve, you do not use fresh wood; rather you find and carve preexisting objects, usually older functional objects such as tools, toolboxes, or ox yokes.*

PG: In *Roundabout* and earlier pieces I had used old wood bought from lumberyards that specialized in recycled wood. *Roundabout* is made of the floor joists of an old Philadelphia factory. The wood has the same quality as the wooden tools, stained, nicked, abraded, the record of its rich history. You can see the history on its surface: the dirt, the grease, the grime. I think I got the idea from di Suvero, from his early stuff where he uses ceiling beams to make pieces like *Hank Champion* in the Whitney Museum collection. That's a great piece. I was using timbers to construct sculpture before figures reentered my work. Reusing wood doesn't originate with me. Maybe the use of tools, old tools, as objects to decorate is something I haven't seen done before, not done before in modern times that is, but everything was decorated in the old days. I have a book of Norwegian Romanesque church carving: doorways, lintels, and furniture. I don't know where I got the first of the old tools, one of the carpenter's planes. As somebody said when I was talking about it, "The wood in those tools is very juicy *because* it's been used." There is a Japanese expression, *shibui*, or something like that, which someone told me is an expression that means the beauty that is conferred on something by use and age. These toolboxes, planes, ox yokes, carts, and breadboards have knife cuts in them, dents, and stains. I'm just continuing what's already been started.

RP: *You described working on the Cree Prophesy (cat. no. 81) in a very interesting way the other day. It was something about the hypnotic nature of woodcarving.*

PG: The thing about a woodcarving is the rate at which the work moves. It's very intoxicating. "You're in the territory," as a friend of mine says. Once you're in the territory, you're a prisoner of the process; nothing changes except the work itself. You go upstairs for dinner, you come back down, and you work until you go to sleep. You wake up in the morning, you have breakfast, you come down, and a little more gets done. That's the only thing you notice from day to day. If you work on a piece for seven months and that's all that happens to you, that's all you're doing, besides eating and sleeping, I mean it's probably like working on an assembly line in a factory. What does a guy who goes into a Ford factory know about the outside world? You get up, you go to work, you come back, you eat dinner, you watch the tube, and you go to sleep. And you do the same thing day after day after day, and the only change you know about is that there are 800,000 more Mustangs in the world. Well on this cart that I carved, *Cree Prophesy*, another register has been created.

RP: *And yet the satisfaction that you must get when it's finished is very different than the person working on the assembly line because they never come to closure, to personal satisfaction.*

PG: When Diego Rivera and Edsel Ford, or one of the people involved in the creation of the Rivera mural at the Detroit Art Institute, were discussing the assembly line process, Ford said that no skilled labor was necessary for an effective assembly line. Everybody performs a single act over and over for years and years. In the case of woodcarving the

intoxication comes from the rhythm and the motion, the concentration, and from the mystery of not knowing what's coming next. I didn't know how the piece was going to turn out, whether it was going to succeed or not. After a while you get good enough at it so there's going to be a modicum of success but at the same time there's a lot of unknowns. Carving wood is an interesting, absorbing act. I call it whittling. You can listen to the radio, you can talk on the telephone; it's a slow process so you do not have to do deep thinking all the time. It's hypnotic.

RP: You also work a lot in bronze. Was the Fate of the Earth Doors *(cat. no. 62) your earliest venture into this medium?*

PG: I started making the panels, which resulted in the *Doors*, in clay in 1984. From the beginning I decided that there were going to be twenty-four of them for a door about the earth. I got into bronze only because someone came along with some wherewithal and said, "Would you like to see some of this clay stuff in bronze." And I said, "That's interesting. Yes, I would like to see them in bronze." I think the first works of mine that were cast in bronze were two clay reliefs, which are on *Roundabout*. You can distinguish them from the others because they were darkened by the shellac release that is put on clay so that the rubber mold will come off. Gradually there were other things that I made in clay that interested the same collector that were cast.

I did not have the money to pay for the casting of the twenty-four panels for the *Fate of the Earth Doors*, intricate as they are, in bronze. So this collector and I worked out an agreement. There's a set in the Cathedral of Saint John the Divine in New York City. But not until 1990 was I able to get a door made of cherry wood to hold a set of the bronze panels. The door has been shown once with the bronze panels in New York City and once with the original clay panels in it.

Since then I have been thinking in terms of bronze on my own and casting things myself, that is not doing the casting myself but taking pieces to the foundry and making things with the intention that they be cast in bronze. I intended to cast *Font* (cat. no. 75) and the *Lidded Vessel* (cat. no. 76) in bronze from the start.

RP: The theme of the Fate of the Earth Doors *is the environment. That is a subject we have not yet talked about. Some of the scenes I can read fairly easily, as for example the destruction of forests and animals. But there are others that are less obvious. Can you shed some light on their subjects?*

PG: Migrating caribou appear on the bottom right-hand front panel. There is a winter forest with leafless trees and animals appearing between them. Below, at the roots of the trees are flames and heads, symbolic of, perhaps, the unfolding catastrophe. Above them, two panels tell about the demise of the vast herds of buffalo on the western plains in the late nineteenth century. There is the clear-cutting of the forest, and there are people who are concerned about what is going on. Here, animals attack a human figure—more heads and flames at the bottom. A man and a woman clutch at each other, and two human heads with hands coming out of their mouths express excitement and horror. Up above are birds and trees. They are symbolic and not dealing with specific events. Over here is the depiction of Big Foot at Wounded Knee in the snow, which comes from a photograph taken on the spot. He was dead frozen. Somebody had propped up his body so that the photograph could be taken. Above that is an image of urbanization, the nightmare of interlocking Los Angeles freeways ending in a huge demonic head. There are even cars in a crash on that highway. But in the middle, one lone tree grows, while in the distance are rows of suburban housing developments. The top panel shows a

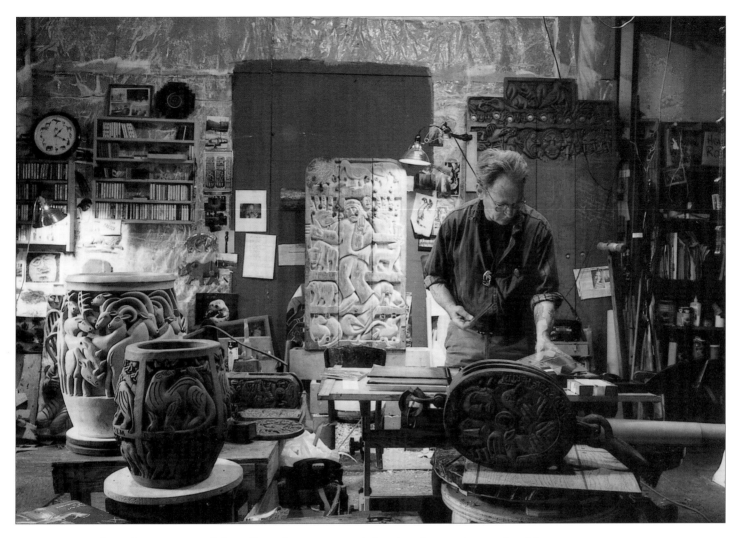

Japanese story about the samurai and the calligrapher who meet by accident. In the original story, they are brothers but don't know it. The samurai ends up killing his brother, the calligrapher, because his brother won't tell him the meaning of courage. In another panel two artists and a soldier appear, and one artist is a musician, the other painter. Then there is a hunting scene—hunters are firing guns at everything that moves in the forest. It's a contest between modern, mechanized human life and the forest with its trees and animals. When I spoke to the museum docents the other day, I asked them who was optimistic and who was pessimistic. Half

raised their hands in each case. I said I was pretty pessimistic, but someone then said, "You're really not pessimistic. You're optimistic because your work is basically an attempt to make people aware of what is going on in the world." Perhaps, I don't know. But anybody who writes, or makes art, or makes music is absorbed and obsessed and swallowed up in the act. Those who make anything lose themselves in what they are involved in. It's hard to tell when you look up and the real world comes back how it is that you see it. And that's what I do.

January 24. 2002

Silence Would Be a Compromise[1]

Lucy R. Lippard

What a moment to be writing about Peter Gourfain's art: *Fall, 2001*— perhaps as decisive a fall as the biblical myth, although hardly without precedent in recent geopolitics. Gourfain has already lived for many years with the contradictions our current situation presents for progressive artists: socially imposed either/or choices between action and contemplation, form and content. As he has wrestled with such unreasonable exclusions, he has forged a unique and dynamic visual solution.

For all his commitment to social justice, what Gourfain does in the face of times like these is what all artists do: make art. Unlike most contemporary production, Gourfain's has never been restricted to the galleries and museums. And unlike most art not restricted to museums and galleries, his is in fact "museum-quality" art, wherever it is found. His production includes not only the paintings, sculptures, pots, and prints shown in "high" art contexts, but striking banners, leaflets, buttons, and graphics that have also been seen in the streets, the meetings, the publications, the demonstrations.

Gourfain counters a fantastic and even humorous imagery with a lyrical, almost elegant beauty. Belief and all its horrors and blessings are confronted by nature and *its* horrors and blessings. An outraged empathy with the poor and oppressed is combined with a highly literate and refined esthetic sense. In addition there is a very contemporary tension between current events and a style originally derived from the Middle Ages. Gourfain may be filled with anxiety for the world, but his hand is firm on pen, knife, or brush.

His real subject is conflict—conflicting motives, conflicting desires, as well as the ancient struggle between good and evil—extremes far more blurred and complex than the fall, 2001 versions.

Before the attack, he made a drum cast in bronze with four reliefs depicting aspects of the stolen election of 2000 (cat. no. 83; 2001). It's possible that such attempts to communicate sorrow and rage are doomed to be an inadequate response. But the responsible artist tries anyway. He focuses on, or rather experiences and then tries to express, the struggle against oppression in self and society, art and life—the struggle that continues, the struggle that is so often misstated, the struggle that obsesses the American people today in an often simplistic, chauvinistic version.

It is impossible to write about anything today without acknowledging the unprecedented times in which we do so. At the same time, for those of us who have been around for several rounds of culture wars, a sense of déjà vu is inescapable. The lessons of Gourfain's work for some twenty-five years become stronger as the weeks go by since September 11, as we watch the manufacture of crisis as well as consent. In 1991 (during the Gulf War), Gourfain wrote prophetically: "The world is so sad and brutal and self righteous. … The U.S. has begun another war. The silence is shocking—the Anti-Arab racism etc. … It'll cost us dearly here in New York I think. … it might not take long to wreck this place and bring on an unimaginable catastrophe. … This is Capitalism's capitol. Its World Headquarters—so we lose by winning." [2]

With typical perversity, Gourfain was apolitical in the 1960s when everyone else was radicalized and reentered the fray in the late 1970s, when many sixties converts had fallen by the wayside. He has had an interesting trajectory since coming to New York.

Beginning as a successful geometric painter and structural sculptor (Guggenheim fellowship, Whitney Annual, prestigious gallery) corralled into the so-

called minimalist movement, by the mid 1970s he had turned to more communicative forms, disillusioned by the careerism and commercialism he saw of the art-world. It might seem that Gourfain "sacrificed" a healthy art-world career in order to become an eccentric idealist. In fact, he appears to have found his own way in the late 1970s and, despite the frustrations of acting beyond the mainstream, remains firmly ensconced in a place uniquely his own. Instead of teaching at an art school, for years he taught painting and ceramics to senior citizens for the Division of Senior Centers of the City of New York, working in Brooklyn. He does visiting-artist gigs around the country. He shows his work at small spaces on the art-world margins and in museums outside New York. He has always loved being an artist but acknowledges ambivalence about the uncertain ethics of the art world. At one point when he felt he was compromising his principles, he recalled a "strange lightheaded sensation. … It was my mother and father, their shades rattling my bones. It was the shade of the Black man on the wooden back porch of a Chicago tenement talking seriously to me about philosophy when I was eight years old."

Born in November 1934, Gourfain grew up in Chicago. His parents came from very different backgrounds, but their shared social integrity and passionate antiracism (a cross was once burned on their lawn when they entertained a black person) made an impression on their son. Gourfain went to public schools and then spent four years at the Art Institute of Chicago, where he made figurative paintings. After working odd jobs for a few years, he moved to New York City, arriving on Halloween 1961, determined to "be free, kick the past in the teeth, do new stuff that was New York."

His first works in New York were figurative paintings based on Brechtian theatre. Then he made a series of 100 abstract woodcuts from scrap wood found on the street, which he gathered into a portfolio. Then, influenced by Lee Lozano's huge screw paintings and David Lee's yellow-on-yellow monochromes, he made some big three-dimensional "gear paintings" that eventually flattened out into minimal lozenges and were shown at the Guggenheim's important *Systemic Painting* show in 1966 and in a solo show at Bykert Gallery in 1967. (The rounded edges of those forms suggested the arched windows in the not-yet SoHo lofts where Gourfain and many friends lived.) As well as Lozano and Lee, he hung out with (among others) Al Brunelle, Abby Shahn, Roy Slamm, and Ted Castle. He was married to actress (now playwright) Janet Noble. In 1966 they had a daughter, Noon, who is now an artist/ electrician living in Brooklyn.

In 1969, Gourfain ran into sculptor Gary Kuehn who persuaded him to take on his School of Visual Arts classes in environmental design and sculpture for six weeks, although Gourfain was strictly a painter at the time. The school then hired him for two years. He began playing around with the students and became a sculptor. He came to clay in a similarly serendipitous manner, when he took a six or seven-year-old Noon to classes at Greenwich House Pottery and started "messing around with clay" as he waited for her. Gourfain's first sculpture show was at Bykert in 1971. In 1969 he had exhibited chalk wall drawings there, and in 1971 he made wall paintings with flat black paint that silhouetted the free-standing stacked-beam sculptures in front of them. In 1972 his fourth Bykert show included the first *Roundabout* and the huge *Seesaw* (inspired by playground duty with Noon and eventually installed at Patrick Lannan's private museum in Palm Beach, Florida). The 1972 Bykert show was off-site. *Sail Sculpture* was installed in a field in New Jersey—a line of ten tall canvas sails on "masts," rising and dipping from one side to the other as though coming about into the wind.

At the same time, from 1970 on, Gourfain was also making large temporary structures in vacant lots, bolting together the rough-hewn wood and beams from recently demolished buildings. At the corner of Stanton and Suffolk Streets on the Lower East Side, for example, he piled over a dozen huge timbers into a shallow tipi-like shape rising from the

rubble. These open-ended gestures merged with the infrastructure of the city he had come to love: "I don't feel like a native, but this is my city. I love the subways and the Metropolitan Museum."

In the late 1960s and 70s, Gourfain's work was always being called "ambitious" by the reviewers. This could have been merely a reference to its large scale but also acknowledged his appetite for big subjects as well as big objects. When his work became more literary, it was called "epic." It may be difficult today to visualize Gourfain as a once-heralded minimalist "in the world of expensive interior decoration," as he came to see it. But his minimalist career has continued to haunt the figurative work.[3] The repetitive forms were easily translated into figuration, where in later readings they became emblematic of the masses, the proletariat, working people.

The first *Roundabout*, in the Bykert show of 1972, had eight columns and was sixteen feet in diameter and seven feet high. It turned, with some effort, on wheels on the outer rim. In 1975, the second *Roundabout* (1974–1981; cat. no. 4) lurked in Gourfain's basement studio on Tiffany Place in Brooklyn as another handsome abstraction, columns rising from a broad base to a slimmer open top. Like the first, it was made of yellow pine, but larger—nine feet high, with twelve columns, and a twenty-two foot diameter, rooted firmly to the ground. Gourfain had just returned from Europe (on a ship, where, in twelve days at sea, he made 200 watercolors of the open ocean). In England, he had seen some barrel columns at the Durham Cathedral that were decorated with deep grooves. He thought he might carve similar marks on the new *Roundabout*, but when he started, the Romanesque style emerged, perhaps from art seen on that trip or perhaps a throwback to the 1950s, when he had been drawn to the Romanesque through some New York Graphic Society books. (He still goes often to the Cloisters "to see my favorite stuff.")

Gourfain's transition from structural sculpture to figuration initially had nothing to do with the Romanesque. He always carries a sketchbook in which he doodles and works out ideas on subways, in parks. (During a stint of Grand Jury duty he made some 400 drawings.) In the 1960s and 70s he never stopped drawing what he calls "cartoons"—wild figurative fantasies that now appear to predict later work. In another apparent detour, he also painted seascapes for years. At first they were abstract waves, probably originating in the Lake Michigan of his childhood. Then boats appeared, sometimes peopled. Gourfain says he has no idea "what made me grab the Romanesque stuff" at that particular point. With hindsight he sees that it offered "a figurative style that was unrealistic but not abstract."

The second *Roundabout* (cat. no. 4)—Gourfain's masterpiece to date—is a fully successful hybrid between the abstract and the figurative. It weaves form, content, social optimism and pessimism, art of the past and present into a fabric that can be "read" for hours. When it was shown in his solo exhibition at the Brooklyn Museum in 1987, it was installed beneath a round skylight. The effect was downright glorious and made it difficult not to see in *Roundabout*'s basic form some reference to the architecture of worship. It rises from a sturdy base like a bell rather than a spire, a Romanesque structure surging slowly up from the roots of its secular place, rather than gothic towers aspiring to heaven.

Space has long been a preoccupation of Gourfain, as it must be for any sculptor. In his "Romanesque" work, the cramped, decorative *horror vacui* seems to derive solely from medieval art. But it was also predicted by aspects of the earlier sculptures. Novelist and long-time friend Ted Castle wrote about Gourfain's 1973 show that the two huge wooden sculptures "were built into the two small rooms of the Bykert Gallery and although they were ultimately designed to be outdoors, they so filled the space and transformed it that they *became* the space. Such could be said of very few other sculptures which are displayed in captivity—they always look unhappy and about to break the walls."[4]

The first overtly political gesture Gourfain made within his art was in the late seventies, when

he carved an image of an Argentine woman viewing with horror the severed hands of one of her daughters in a police station. He credits activist and journalist Maureen Mehan, his partner at the time, with much of the impetus toward this subject matter. By 1981, the columns of *Roundabout* were carved inside and out, wood panels alternating with clay inserts. (These solved the health problem of toxic dust generated by carving the yellow pine, source of turpentine, with high-speed rotary tools and without a mask.) Low relief is played against high relief. The bristling details crowd upward like the sculpted facades of the great Romanesque churches, both monumental and intimate, a book of many stories, while the sculptural whole maintains its silence.

Despite its medieval roots, *Roundabout* is cinematic in its visual speed and narrative in its intensity. "Just tell the story and make it good and true," says Gourfain, "and they'll forget all about you and pass the story on which is the point anyway." When the sculpture was shown at the Brooklyn Museum in 1987, he wrote a "key" for a public handout at the museum's request. Gourfain wrote at the time that it didn't occur to him that such a key to the images was even necessary: "I had thought that since they are all, almost without exception, decorations to something else, that they should flow on like music and that, slowly, with each successive look, they could be understood in their context." [5]

Although the underlying forces are immediately recognizable, this is in a sense wishful thinking. Specific subjects demand captions. Why frustrate or mislead the viewers? Despite the powerful narrative drive, the inexorable forward motion of image after image, Gourfain's carvings and drawings are deliberately general rather than specific in effect. As a result, he has been lauded for and accused of being a "humanist"—a term that has become anathema to the Left, implying a wistful liberal vagueness and inability to come to grips with the real issues. But in Gourfain's case, humanism is a deeply felt position combining anger and hope, personal and political motivations. He has never had to "code" his art for

different audiences. The demonstration banners and the museum paintings are similar in style and content. The unmistakable anguish and passion expressed in his boldly cut figures and faces, his surfaces teeming with action, are globally applicable. As banners, the powerful images read themselves into whatever struggle they are displayed within. The figures looked Irish for the H-Block Committee, Latino in the Central American context, African when applied to the anti-Apartheid movement. Today, they might be American or Afghani or Palestinian. The stories remain all too similar.

The staggering breadth of subject matter in Gourfain's work includes portraits of Vincent van Gogh, James Joyce, Martin Luther King, Jr., Malcolm X, Maurice Bishop, Vladimir Tatlin, New York graffiti artist Michael Stewart who was murdered by the police, and black vernacular artist William Taylor; the victory of the Nicaraguan revolution, scenes from *Ulysses*, the Ku Klux Klan, brutal cops, the murder of Fred Hampton, the Greensboro massacre, Irish hunger strikers, artists brandishing paintbrushes; boat people and people in boats, businessmen and workers fighting it out, the boat carrying Tristan and Isolde from Ireland, and A Last Supper (as opposed to *The* Last Supper; there is no Jesus but there is a Judas "holding his face in his hand, while the other holds the blood money"). There are figures sleeping, dreaming, smashing light bulbs (a scene from the Nighttown section of James Joyce's *Ulysses* where Stephen Daedalus takes his cane, or ash plant, and smashes a chandelier). There are tugs of war, berserk meals, a man playing a horseshoe crab like a violin (the ancient creature is a favorite motif). There are scenes of war and scenes from nature. I could go on and on.

By 1980, off and running with his Romanesque style, Gourfain was making prints, pots, paintings, and polemics for various causes, among them a stunning button of artists rising from revolutionary flames that was the emblem of Artists Call Against U.S. Intervention in Central America. Living in Ohio for a period on an NEA grant, he made the

untitled ten "Ohio Pots," actually large urns. Noon, then in her early teens, collaborated on the tenth one. "I wanted walls to paint and carve on," Gourfain recalls. "And this was a way of creating a mini-architecture I could decorate." He had discovered that "the secret is to attach the stuff to the sides of jugs and urns—and tools of various kinds and to abhor the vacuum as they did in R[omanesque] A[rt]. … Decorate!" Around the same time, he was reading *Early Irish Myths and Sagas* and wrote: "It's very weird and beautiful, completely odd—endless bloodletting and built on a rhythmic sequence of lies—call them whatever you want—exaggerations." Those rhythmic sequences are the backbone of his own work. The Romanesque-derived style allows him to mix and weave life, politics, nature, figures, objects, plants, and animals with endless inventiveness and a modern urgency.

Wood and clay are the artisan's mediums, often divorced from art today by a snobbish distinction between high and low art, or fine art and craft. Gourfain's sculpture, even the minimal works, can be seen as homages to labor—to construction workers and boat builders and others who work with their hands and bodies. *We're All in the Same Boat* is a caution that takes on new meaning in fall 2001. Boats often figure prominently in Gourfain's work (see, for example, cat. no. 25; 1983), while the figures surging forward on a beam or narrow band suggest the carved figureheads on great sailing ships. His respect and compassion for the working class can be interpreted not only through the images but in the medium of carving itself and sometimes in the objects carved. These include a toolbox, a dolly, a pulley, a block, a nailbox, ox yokes, carpenter's joiners, and a plane given him by an old man in Brooklyn. Gourfain is a populist in the progressive sense of the word, and his viewers get it. (A curator remarked that his opening at the Brooklyn Museum was the only integrated one she had ever seen there.) Yet his own motives for using these objects is basically esthetic: "They're beautiful compact chunks of wood, sometimes with blades or chunks of metal

in them, that have acquired this beautiful patina with use."

Gourfain is also "a lover of language who distrusts what people say," says Ted Castle.[6] In all of his work, literary references abound, from Aristophanes to Shakespeare ("What folly I commit I dedicate to you"; cat. no. 66; 1998) to Jonathan Swift (his epitaph: "Here Lies Jonathan Swift Where Savage Indignation Can No Longer Lacerate His Heart"; cat. no. 52; 1993) to one of his favorite books, Joyce's *Finnegans Wake* (cat. no. 37; 1990 and others). "JJ was a Socialist when he was young," he says. "Nora kept him honest and a pacifist." Where Joyce plays with puns, creating a great wave of language that in turn recreates itself again and again, Gourfain plays with the visual counterparts, images that render double and multiple meanings, cresting in frustration or rage or admiration. Like Joyce he works between the comic and tragic. Nothing is serious; everything is serious. Often he concocts his own alphabets. The scattered messages can be hard to decode, so they don't immediately intrude; there is time for the nonverbal message to sink in. We get the spirit before we get the letter.

Ever since a hearing-disabled man handed him a card on the subway, Gourfain has also used American Sign Language, as in the 1993 linocut that reads "When Money Speaks Truth is Silent." "It was a way to use the alphabet as a graphic element, so I could put messages on the pieces," said Gourfain. "If you didn't care about the messages, it didn't matter. It looked good anyway." The hands spewing from mouths and faces on so many works recall precedents in the early sketchbooks. Gourfain cites a variety of ancient visual sources: the Hand of Fatima, Roman imagery, Christian reliquaries, Pre-Columbian hands in which the fingers become figures. Another parallel is the La *Mano mas Poderosa* (The Most Powerful Hand), often used in popular religious art and contemporary Chicano art as a symbol of people's power. In the sculptures, Gourfain adds the arm to give the hand height and stature. *Mamarojo* (commemorating the assassinations of

Martin, Malcolm, Robert, John; cat. no. 63; 1997), for instance, is a variation on Joyce's "Mamalujo" (Matthew, Mark, Luke, and John). Some of the hands have reached monumental scale, like *Powerful Days*), eight feet tall and cast in bronze as a commission for P.S. 6 in Brooklyn in 1997. It features scenes from the high points of the Civil Rights Movement, from Rosa Parks to demonstrators being fire-hosed in Montgomery to Mississippi voter registration to Martin Luther King, Jr.'s "I Have a Dream" speech.

With the return of figurative work, Gourfain had scaled down the actual size of his art, a necessity in the new mediums and nonmainstream economics. Yet without much fanfare from the field, he has made several public art pieces, including *Stele for the Merrimack*, an eight-foot high bronze for the National Park in Lowell, Massachusetts, the only national site devoted to Labor. Prime among the public works are two sets of bronze-paneled doors, the first executed during a summer course in collaboration with students and faculty at Kent State University in 1980. Many of the students had no art background, and Gourfain recalls that the strongest panel was made by a former beauty queen. The *Kent State Doors* (1980; cat. no. 24), commemorating the terrible event of 1970, were once in an exhibition commemorating May 4, 1970, but the administration was reluctant to be associated with the murders.[7] At this writing they are still in the artist's storage.

The second doors, begun in 1984, have had better luck. *Fate of the Earth* (1997; cat. no. 62) was cast in seven bronze editions, one of which is set into a wall at the Cathedral of Saint John the Divine in New York. Another set will soon be doors for a new art museum at Duke University. *Fate* represents another thread of Gourfain's social engagement and perhaps a softer side to his art. As an ecological statement, it joins other works that marvelously intertwine a vocabulary of animals, birds, shells, fish, trees, plants—among them the self-explanatory *Carmageddon* (1998; cat. no. 64). *Cree Prophecy* (2001; cat. no. 81), carved on a wooden cart Gourfain found sitting outside the door of his studio/home in Bedford Stuyvesant, depicts a litany of natural loss: "Only after the last tree has been cut down, the last river has been poisoned, the last fish has been caught. … Only then will you know that money cannot be eaten."

The doors are just another example of Gourfain's eclectic art-historical sources. The dominant Romanesque rhythms can blend with Ethiopian Coptic frontality and Celtic *entrelac*. For all his fascination with its history and art, Gourfain has been to Ireland only once, in 1956, but hopes to return soon to consider survivors' narratives from the 1916 Easter uprising. A voracious reader, he finds a good deal of inspiration in recent pasts as well. "Did you know [van Gogh] was not only a Socialist but very interested in feminist ideas?" he once asked, quoting an 1889 letter that might have been his own credo: " ... perhaps we exist neither for the one thing nor for the other, but to give consolation or to prepare the way for a painting that will give even greater consolation ..."

Sometimes it's easier for Gourfain to deal with artists from the past than with the present, given the flawed and commercially driven art-world in which we work today. Like many artworkers dissatisfied with the role of art in contemporary society, he has asked himself: "Why am I an artist? It's not something you do if you want to live in *this* world … You can't become famous without being changed by it." He has little sympathy for those artists who have made it big and have paid the price in integrity. His own relationships with dealers and collectors have occasionally been stormy. These dilemmas are reflected in his art. A 1988 ceramic relief incorporates four bands of text reading, "Some Wanted Gold and Power/ Some Didn't. Got It Anyhow/ Some Never Wanted It. Still/ Don't. Never Will." One of the images is a soldier holding a gun accosting an artist holding a brush. (This and other pieces are signed with enigmatic epigram—sort of an EMX—his "tag" in an invented alphabet.) A six-foot terracotta hand and arm displaying similar conflicts is called *The Artist in New York* (1990–1991;

cat. no. 38); in *The Fame Game* (2001; cat. no. 84), two artists duel with ladders—a recurrent motif readable as a warning against the crooked ladder of success. Another motif that reappears over the years is chairs—upside down, strewn around a table, imprisoning and entangling frantic figures. They have their source in a drawing attributed to the fifteenth-century Flemish artist Roger van der Weyden in which men are shoveling chairs. Gourfain has used them to suggest "being mired in something difficult," stuck in the social structures and breaking out of them.

A 1988 print of two bands of heads in reversed directions spewing objects is subtitled *Much Has Been Said. Now Much Must Be Done.* These profiled heads have become Gourfain's trademark. They are mostly men (many could be self-portraits). They cry out to be heard in a virtual hunger for expression and self-determination. They burst out of relief into three-dimensional space or out of their multiple comiclike frames as though demanding to be heard. When they can, they talk back. Sometimes they are silenced by a conglomeration of objects that might block speech, facilitate it, or empower it. Words are literally objectified as hands, hinges, knives, eyes, fish, tools, books, nails, and everything else under the sun. Someday a psychiatrically obsessed critic is going to have a field day with these images of oral fixation, but the work's symbolic force overpowers psychological second-guessing. It's an apocalyptic burlesque show. ("Take a friend you can't talk to," Gourfain recommended when one of his shows was up.)

What finally distinguishes Gourfain's art is its peculiar *energy*. All the passion, tenderness, and rage he feels for the world is channeled (or captive) in the work, which exudes a cantankerous *generosity*—another one of my personal criteria for good art. He puts into each piece everything that he's got, all the moral force of his convictions and his doubts. An outreaching artist in a society where there is no real context for art, Gourfain, like all artists, would rather stay forever in his studio, at work. Instead, he

is driven by both his talents and his compassion to move out, to understand daily life around him, only to be driven back into the studio again, powerless to do more than make images that may never find their proper context. Through it all, Gourfain remains a true formalist, an artist who uses form to communicate content. "I'm working on something new," he wrote once, "a true Romanesque decoration in ten frames. Rather than tell you what it's about, suffice it to say I'm struggling with the color and the style of the faces and figures to give it the Tension and the Stillness that I want."

NOTES

1. The title is based on Amiri Baraka ("A compromise would be silence"), found in *The Vintage Book of African-American Poetry* ed. Michael S. Harper and Anthony Walton (New York: Vintage Books, 2000), 232.

2. Quotations by the artist are from phone interviews and personal letters unless otherwise noted.

3. Michael Brenson wrote in the *New York Times* (April 3, 1987) about Gourfain's move from "minimal" to "maximal," but felt there was "too much going on" in the new works. He compared them unfavorably to those of Serra and Judd, concluding that Gourfain's work was, finally, "limited." To which the artist quipped: "From now on—P.G. Ltd.!"

4. Ted Castle, "Peter Gourfain: Seafarer Plies His Troth," *Art in America* 67, no. 3 (May–June 1979): 130.

5. Peter Gourfain, untitled statement with Charlotta Kotik, "Peter Gourfain: A Tug of War Between Good and Evil," *American Ceramics* 3, no. 4 (1987): 24.

6. Ted Castle, in *Peter Gourfain: M.O.A. Gallery* (New York: M.O.A. Gallery, 1982), [2].

7. Thirty-one years later, there is still no memorial at Kent State. Robert Smithson's "woodshed," not intended as a memorial, became one until it was destroyed; George Segal's proposal did not go through either.

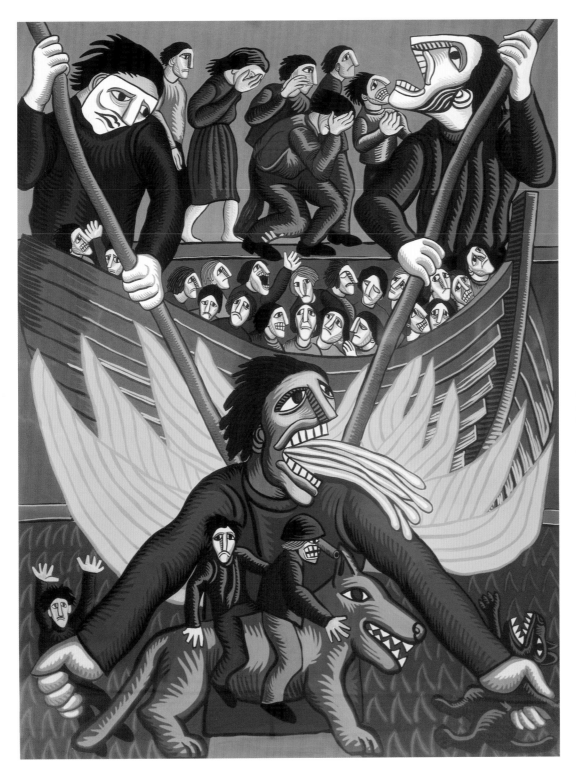

Color plate 1
Charon, 1977
Tempera on paper
67 x 51 ³/4 inches
Collection of Stephen and
Pamela Hootkin
Photo courtesy the artist

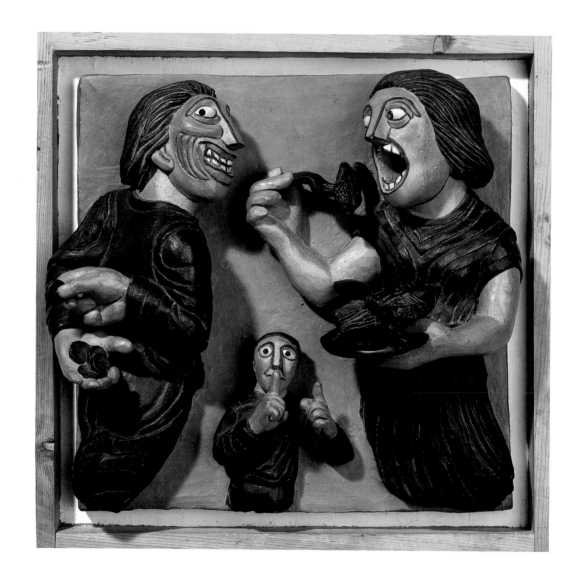

Color plate 2
Untitled Relief, 1979,
Terracotta with oil paint
11 x 11 $\frac{1}{2}$ x 4 $\frac{3}{4}$ inches
Collection of Max and
Beth Callahan

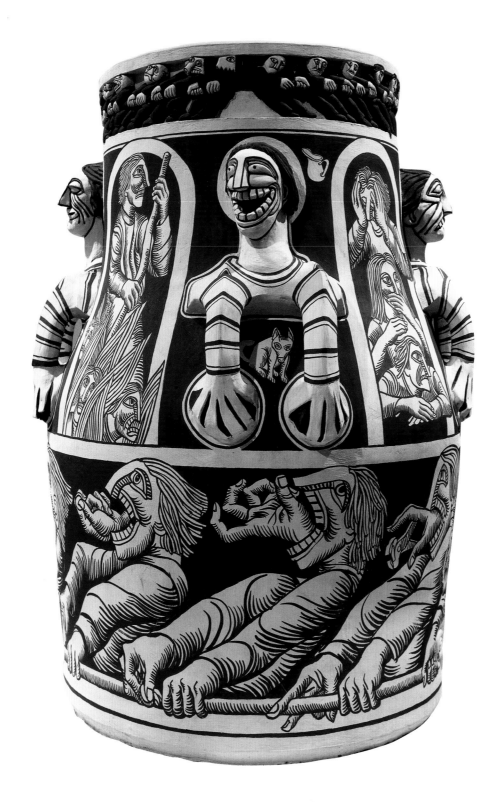

Color plate 3
Untitled #7 from *Ohio Pot
Series*, 1980
Terracotta with white slip
and iron oxide, H. 40, Diam.
30 inches
Collection of Margot and
Leonard Gordon

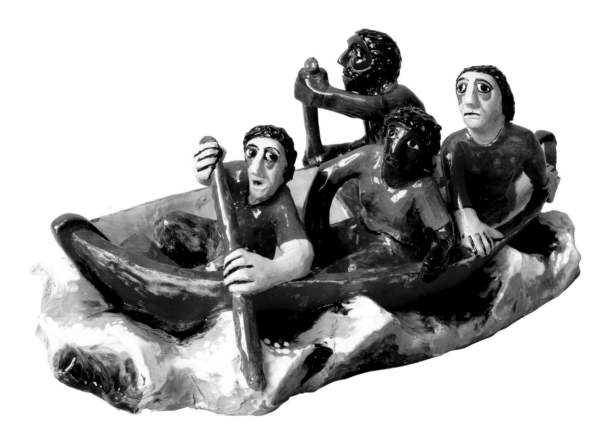

Color plate 4
Boat with Four Figures, 1983
Terracotta with glaze
5 $\frac{5}{8}$ x 14 $\frac{1}{4}$ x 8 inches
Collection of Stephen and
Pamela Hootkin

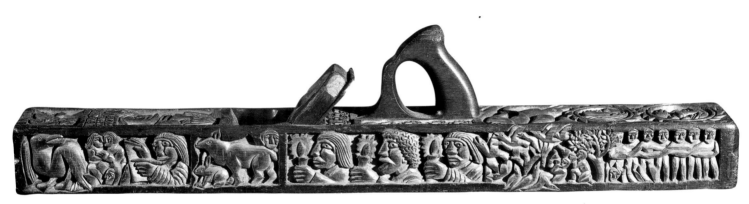

Color plate 5
For Michael Stewart,
1986–1987
Carved wooden carpenter's
jointer, 3 x 36 x 3 inches
Courtesy of the artist

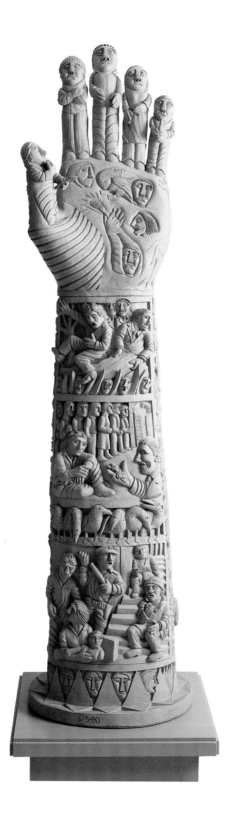

Color plate 6
The Artist in New York
1990–1991
Terracotta
71 x 19 x 17 inches
Collection of Stephen and
Pamela Hootkin

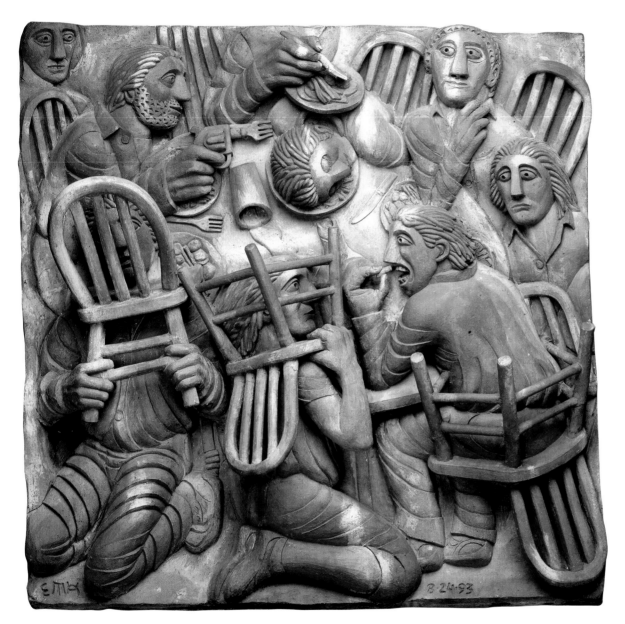

Color plate 7
A Last Supper, 1993
Terracotta
36 ¹/₂ x 36 ¹/₂ x 11 inches
Elvehjem Museum of Art
Delphine Fitz Darby
Endowment Fund purchase,
2002.1

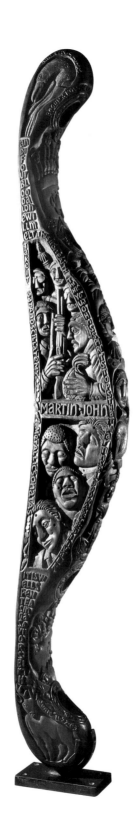

Color plate 8
Sculpture for the Blind
dated 7.19.94 inside face
Carved yoke, maple wood
on black swivel base
H. 72 x 10 x 6 inches
Collection of Monica and
Rick Segal

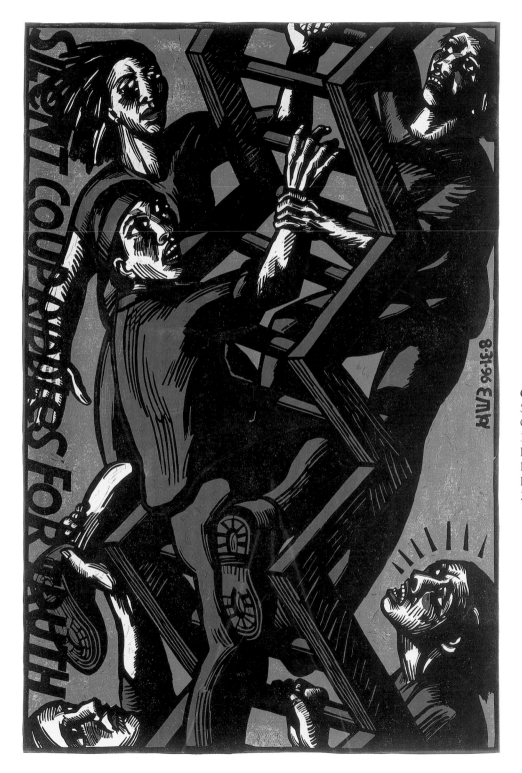

Color plate 9
Silent Coup, 1996
Color linoleum cut, 52 $\frac{1}{4}$ x
35 $\frac{1}{8}$ inches (image size)
Elvehjem Museum of Art,
Delphine Fitz Darby
Endowment Fund purchase,
2001.55

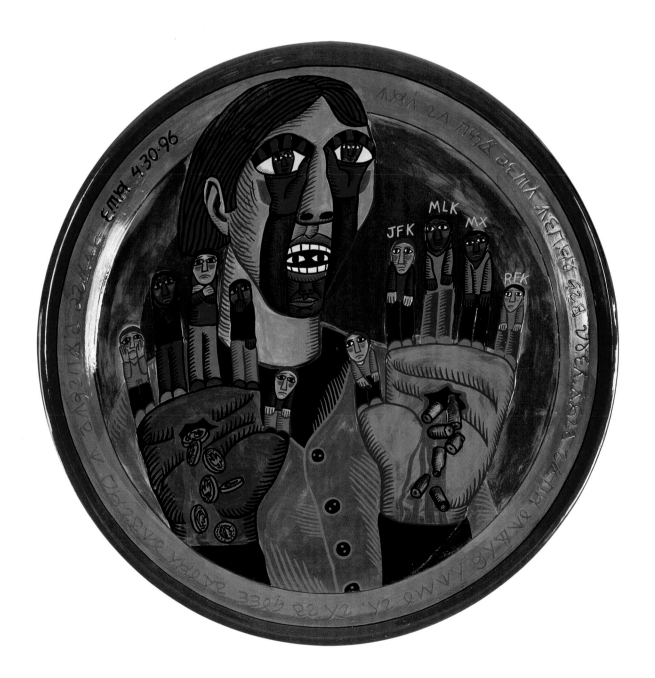

Color plate 10
Hands, 1996
Terracotta with glaze
Diam: 21, D. 2 1/4 inches
Courtesy of the artist

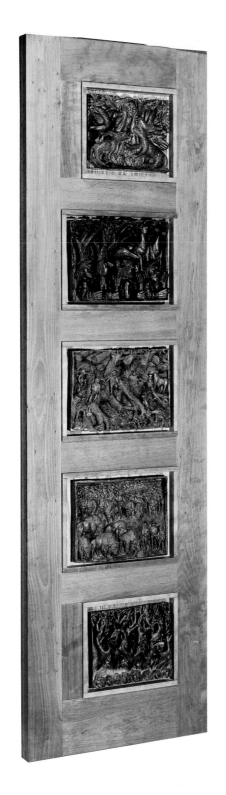
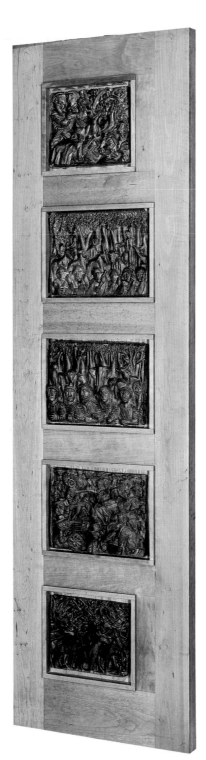

Color plate 11
Fate of the Earth Doors, 1997
20 bronze panels, cherry
wood, 114 $^1/_2$ x 66 inches
Courtesy of the artist

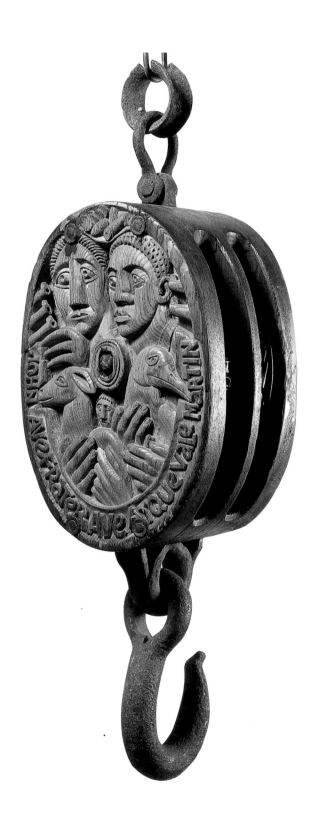

Color plate 12
Awa to Ealdre, 1997
Carved wooden pulley, steel
27 x 11 x 7 inches
Courtesy of the artist

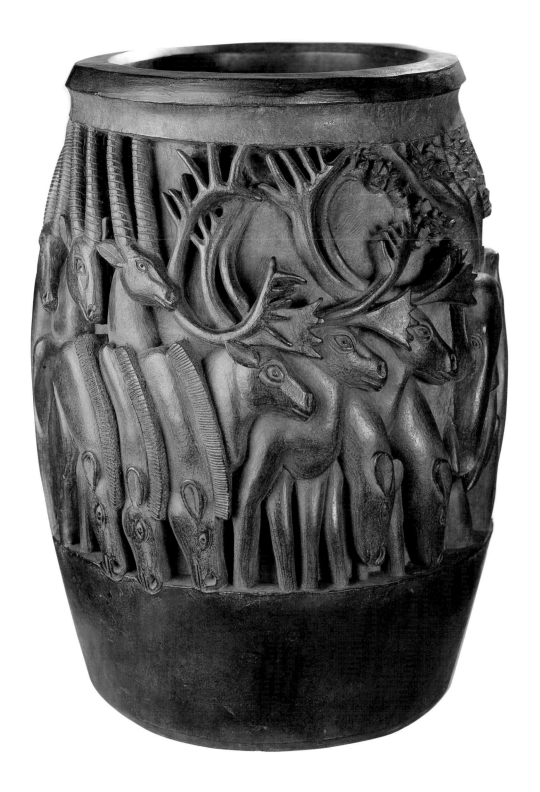

Color plate 13
California Urn, 1998
Bronze
H. 22, Diam. 16 inches
Courtesy of the artist

33

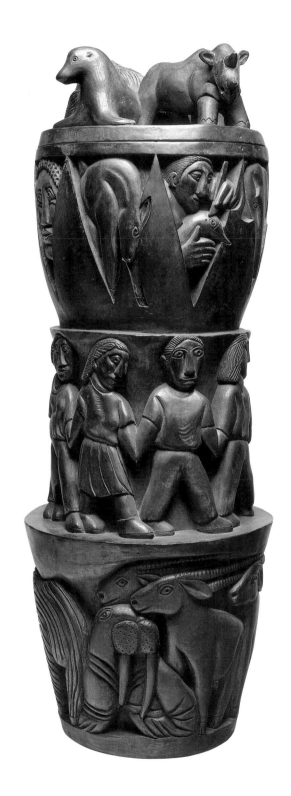

Color plate 14
Animal Vessel, 1998
Terracotta
H. 16, Diam. 8 ¹/₂ inches
Courtesy of the artist

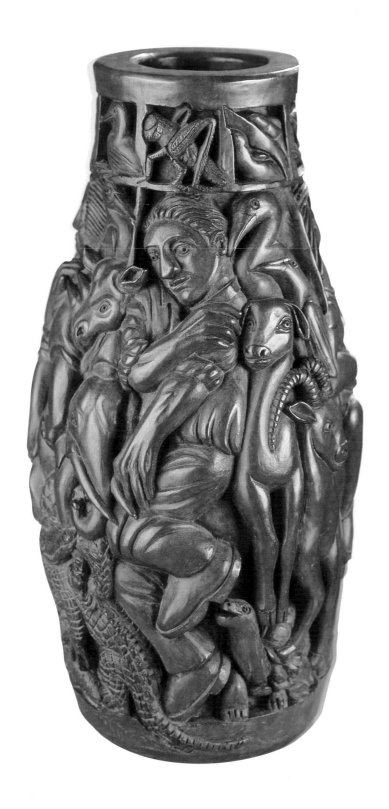

Color plate 15
Lidded Vessel, 2000
Bronze
H. 26 ¹/₂, Diam. 10 inches
Courtesy of the artist

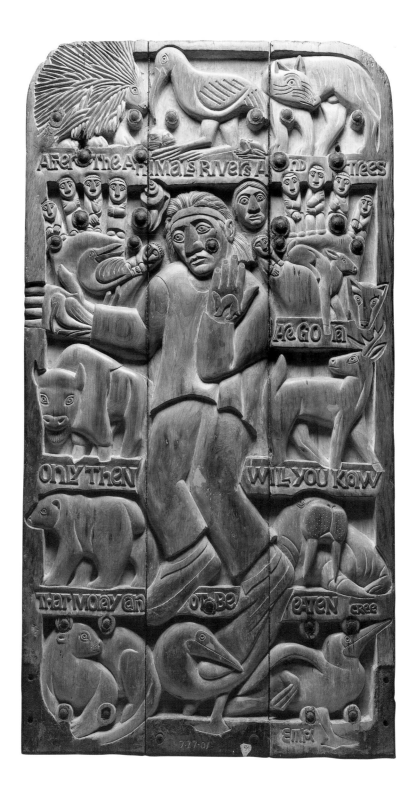

Color plate 16
Cree Prophesy, 2001
Wood, steel, rubber
50 x 27 inches
Courtesy of the artist

CHECKLIST

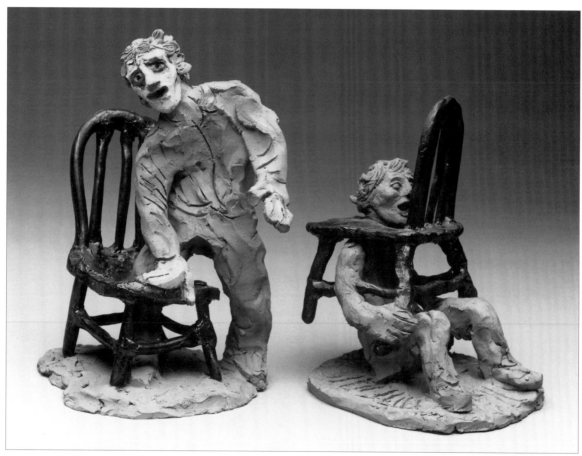

Cat. no. 1
Untitled, 1976, terracotta with glaze
9 $^{1}/_{2}$ x 6 x 6 $^{1}/_{2}$ inches
Courtesy of the artist

Cat. no. 2
Untitled, 1977, terracotta with glaze
8 $^{1}/_{4}$ x 6 $^{1}/_{2}$ x 5 $^{3}/_{4}$ inches
Courtesy of the artist

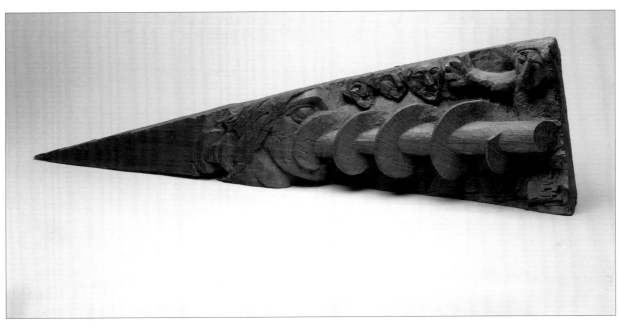

Cat. no. 3
Auguries, 1976, carved yellow pine, 9 x 33 x 4 in.
Courtesy of the artist
*Not in exhibition

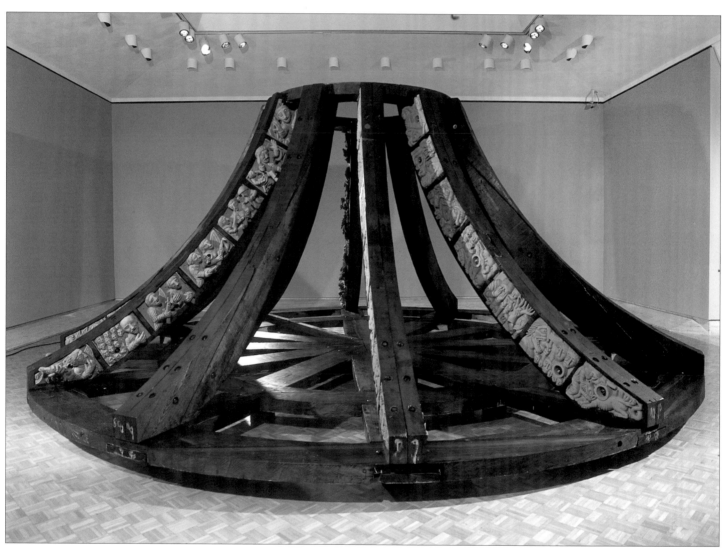

Cat. no. 4
Roundabout, 1974–1981, yellow pine, terracotta, H. 108, Diam. 264 inches
Courtesy of the artist

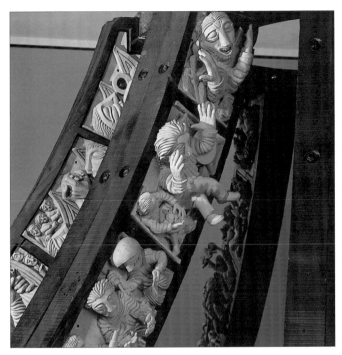

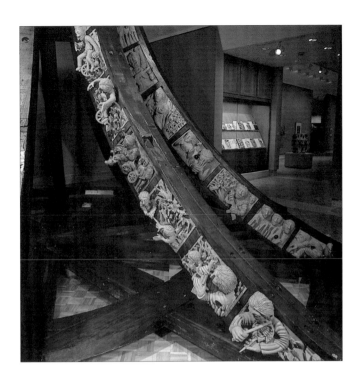

Four details of *Roundabout*, 1974–1981

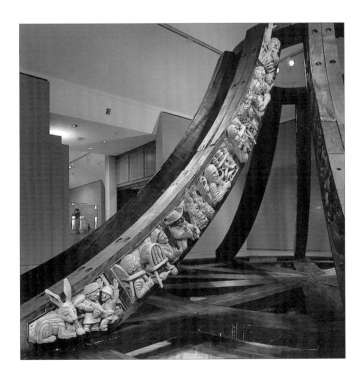

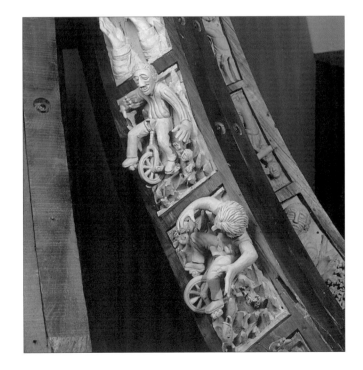

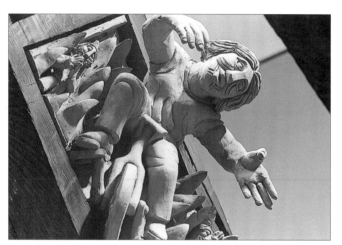

Eight details of *Roundabout*, 1974–1981

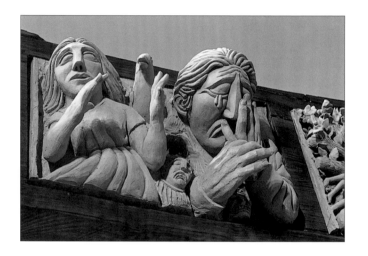

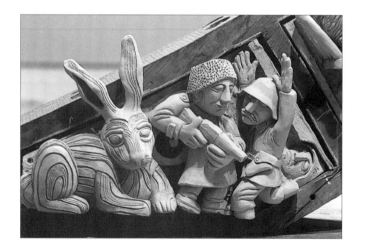

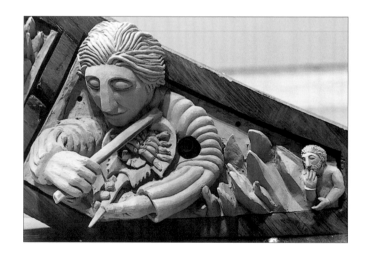

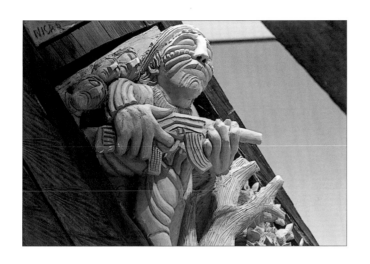 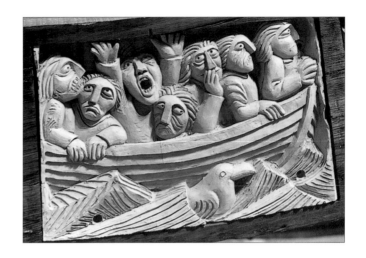

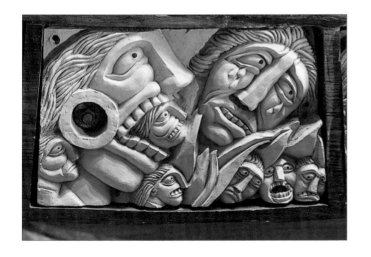 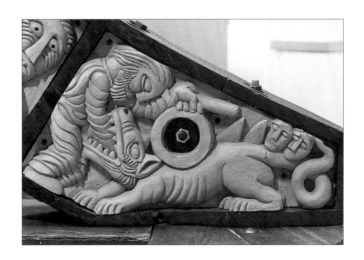

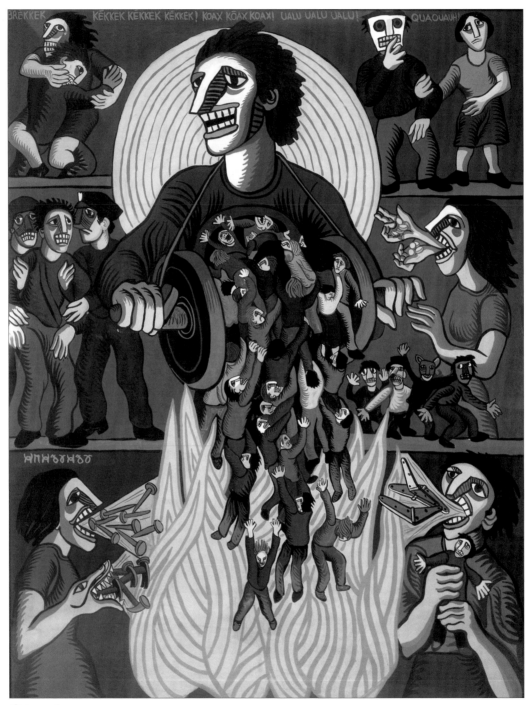

Cat. no. 5
Brékkek Kékkek Kékkek Kékkek! Kóax Kóax Kóax! Ualu Ualu Ualu! Quaouauh! (Man Dropping People into Hell)
from The Frogs *by Aristophanes, quoted by James Joyce in* Finnegans Wake, 1977
Tempera on paper, 67 x 52 ¹/₂ inches
Collection of Betsy Nathan

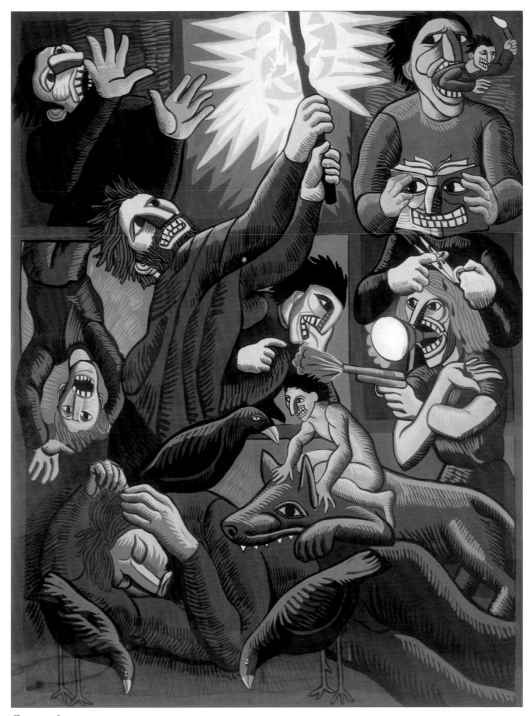

Cat. no. 6
Shattering glass and toppling masonry … (from Ulysses by James Joyce), 1977, tempera on paper, 67 x 51 ³/4 inches
Collection of Stephen and Pamela Hootkin

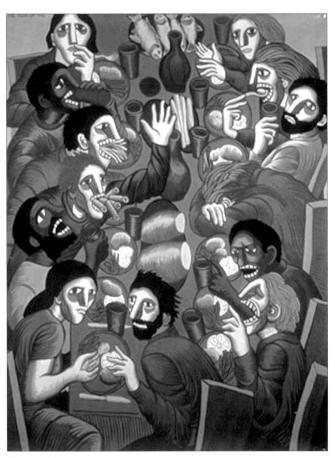

Cat. no. 7
Last Supper, 1977, tempera on paper, 67 x 52 inches
Private Collection
*Not in exhibition

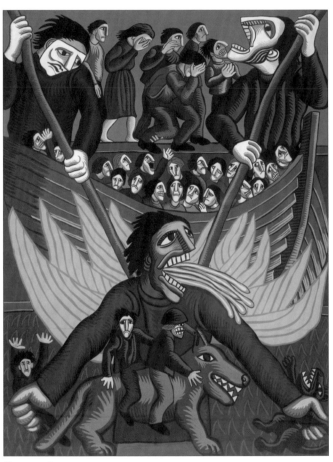

Cat. no. 8
Charon, 1977, tempera on paper, 67 x 51 ³/₄ inches
Collection of Stephen and Pamela Hootkin

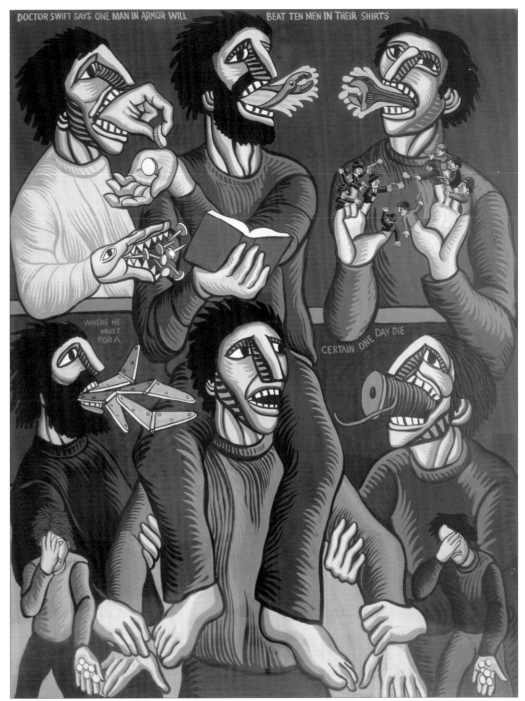

Cat. no. 9
Dr. Swift says: "One man in armour will beat ten men in their shirts," 1977, tempera on paper, 67 x 52 inches
Collection of Nina and Steve Schroeder

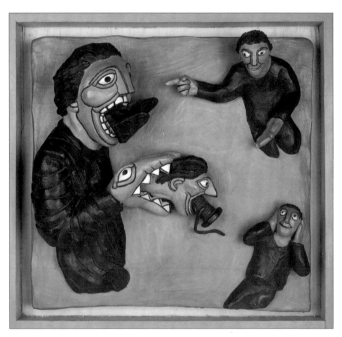

Cat. no. 10
Untitled Relief, 1978, terracotta with oil paint
13 x 14 x 6 inches
Private collection
*Not in exhibition

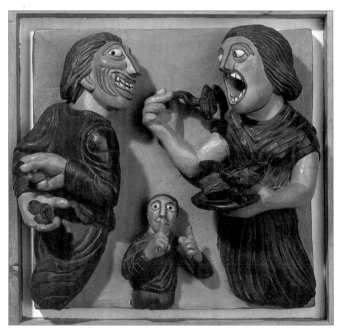

Cat. no. 11
Untitled Relief, 1979, terracotta with oil paint
11 x 11 $^1/_2$ x 4 $^3/_4$ inches
Collection of Max and Beth Callahan

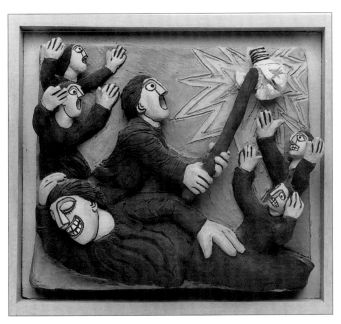

Cat. no. 12
Untitled Relief, 1979, terracotta with oil paint
11 $\frac{1}{2}$ x 13 x 4 $\frac{3}{4}$ inches
Collection of Martin Melzer

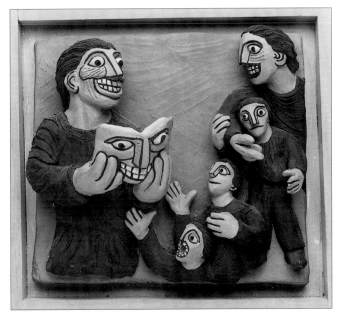

Cat. no. 13
Untitled Relief, 1979, terracotta with oil paint,
12 $\frac{1}{2}$ x 11 $\frac{1}{4}$ x 5 $\frac{1}{2}$ inches
Collection of Martin Melzer

49

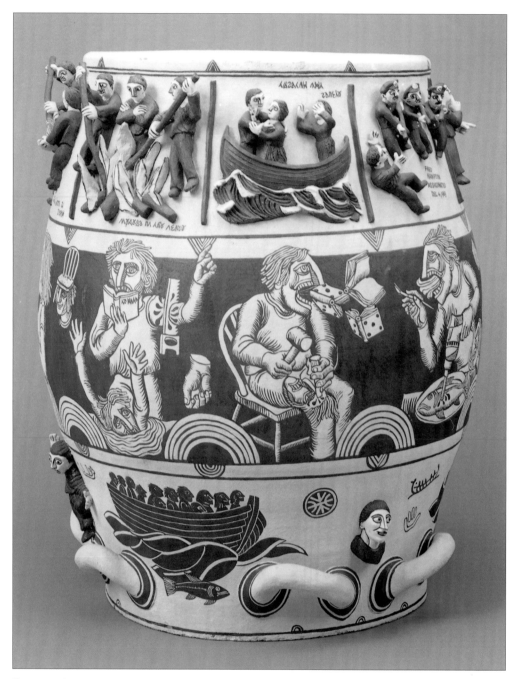

Cat. no. 14
Untitled Narrative Vessal, 1979, terracotta with white slip and iron oxide, H. 31 $^1/_2$, Diam. 26 inches
Collection of the Charles A. Wustum Museum of Fine Arts, gift of Karen Johnson Boyd

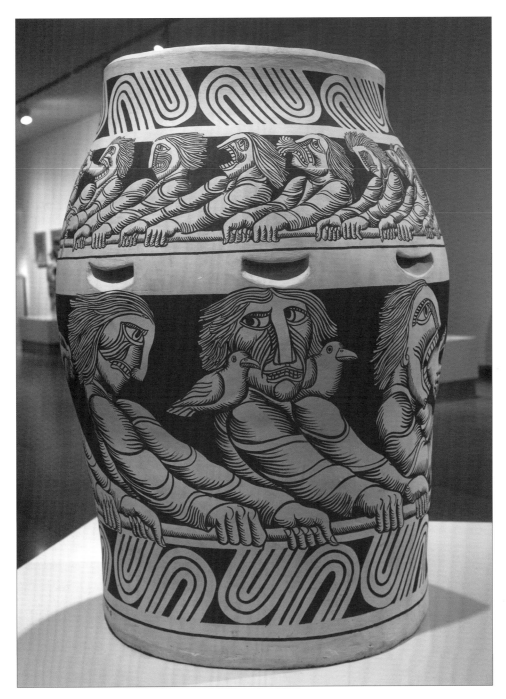

Cat. no. 15
Untitled #1 from *Ohio Pot Series*, 1980a, terracotta with white slip and iron oxide, H. 41, Diam. 33 inches
Private collection
*Not in exhibition

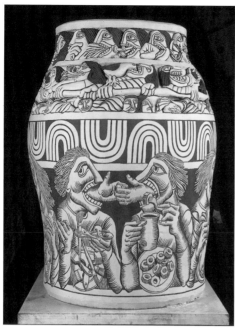

Cat. no. 16
Untitled #2 from *Ohio Pot Series*, 1980b, terracotta
with white slip and iron oxide, H. 40, Diam. 30 inches
Private collection *Not in exhibition

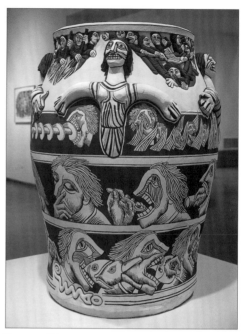

Cat. no. 17
Untitled #3 from *Ohio Pot Series*, 1980c, terracotta with
white slip and iron oxide, H. 41, Diam. 33 inches
Private collection *Not in exhibition

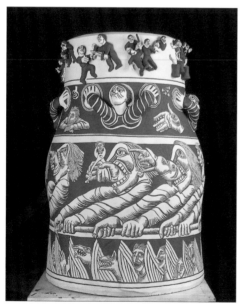

Cat. no. 18
Untitled #4 from *Ohio Pot Series*, 1980d, terracotta with
white slip and iron oxide, H. 41, Diam. 33 inches
Private collection *Not in exhibition

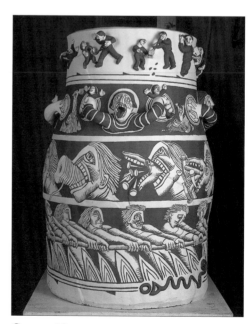

Cat. no. 19
Untitled #5 from *Ohio Pot Series*, 1980e, terracotta with
white slip and iron oxide, H. 40, Diam. 30 inches
Private collection *Not in exhibition

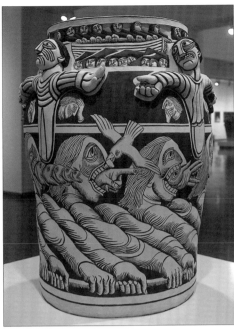

Cat. no. 20
Untitled #6 from *Ohio Pot Series*, 1980f, terracotta
with white slip and iron oxide, H. 41, Diam. 33 inches
Private collection *Not in exhibition

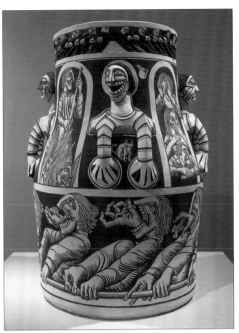

Cat. no. 21
Untitled #7 from *Ohio Pot Series*, 1980g, terracotta
with white slip and iron oxide, H. 42 ¹/₂ , Diam. 33 inches
Collection of Margot and Leonard Gordon

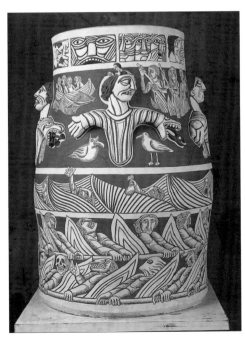

Cat. no. 22
Untitled #8 from *Ohio Pot Series*, 1980h, terracotta
with white slip and iron oxide, H. 40, Diam. 30 inches
Private collection *Not in exhibition

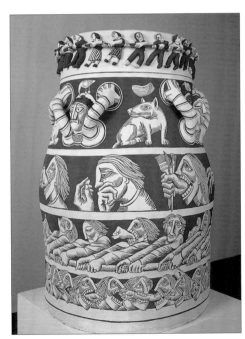

Cat. no. 23
Untitled #9 from *Ohio Pot Series*, 1980i, terracotta with
white slip and iron oxide, approx. H. 41, Diam. 33 inches
Private collection *Not in exhibition

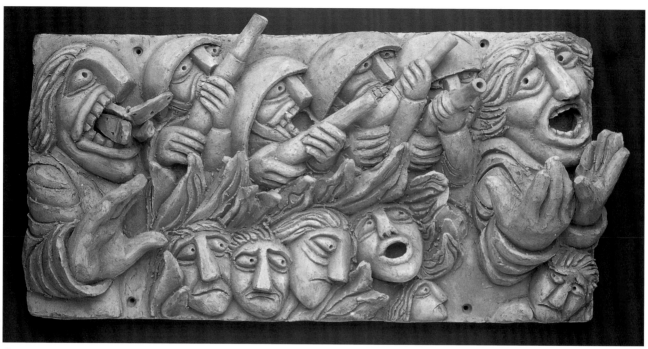

Cat. no. 24
Panel from Kent State Door, 1980, terracotta, 11 x 23 1/$_2$ x 5 3/$_4$ inches
Courtesy of the artist

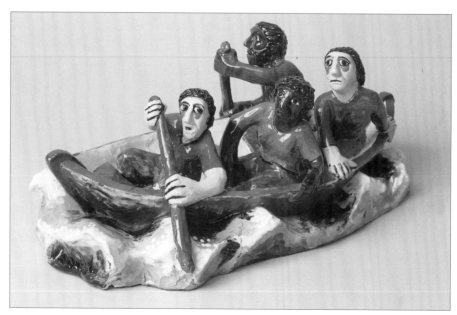

Cat. no. 25
Boat with Four Figures, 1983, terracotta with glaze, 5 5/$_8$ x 14 1/$_4$ x 8 inches
Collection of Stephen and Pamela Hootkin

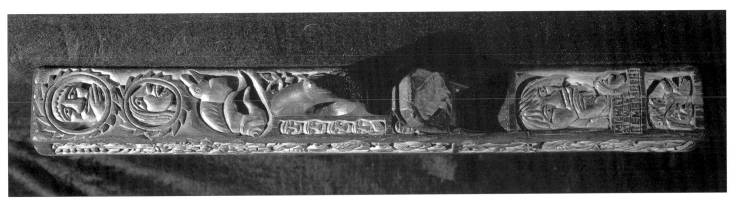

Cat. no. 26
For Michael Stewart, 1986–1987, carved wooden carpenter's jointer, 3 x 36 x 3 inches
Collection of Martin Melzer

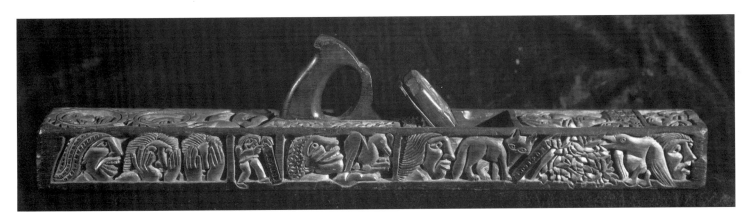

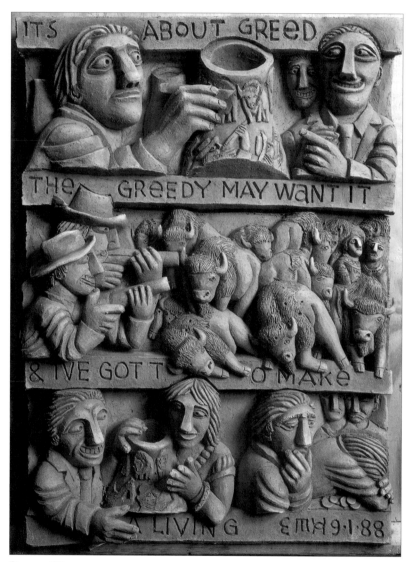

Cat. no. 27
Buffalo Bill, 1988 terracotta, 27 ½ x 20 ½ x 4 inches
Courtesy of the artist

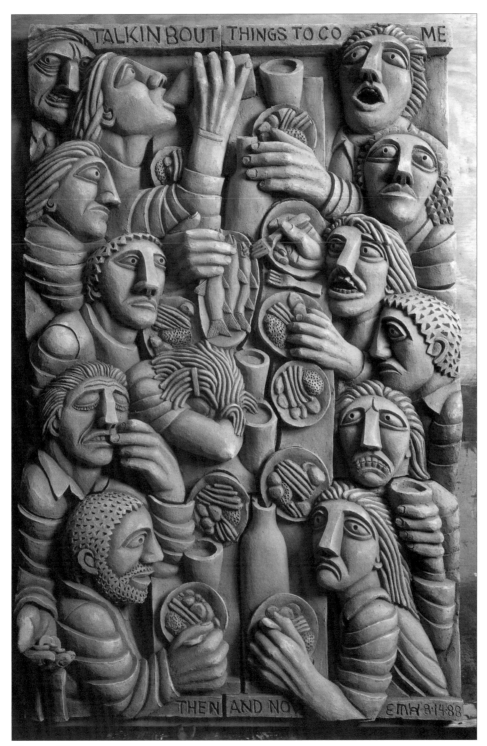

Cat. no. 28
A Last Supper, 1988, terracotta, 42 ¹/₂ x 27 x 8 inches
Collection of Judith S. and Martin F. Schwartz

57

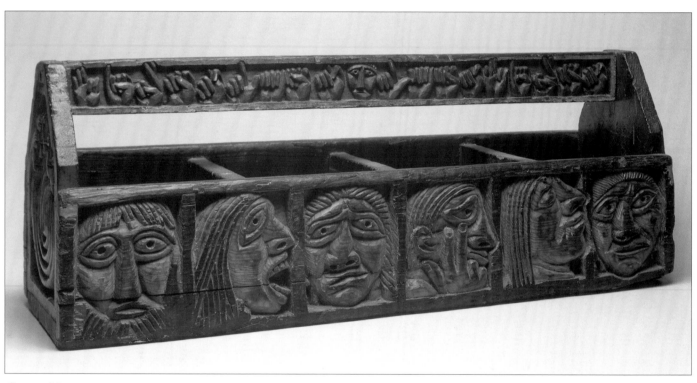

Cat. no. 29
First Last, Last First, 1988, carved wooden carpenter's nailbox, 9 ¹/₂ x 26 ¹/₄ x 7 inches
Courtesy of the artist
*Not in exhibition

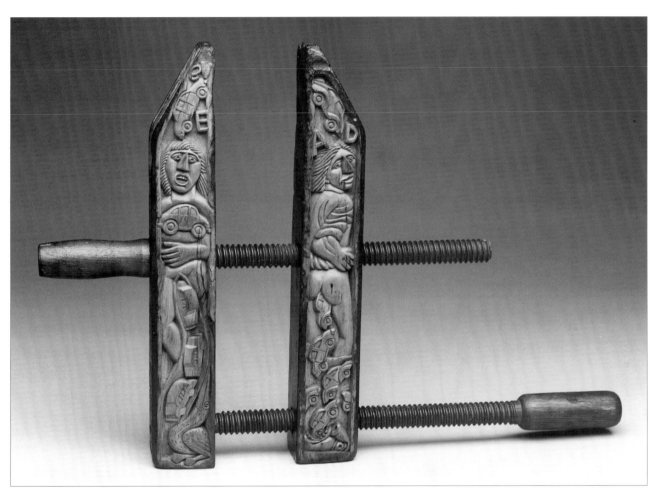

Cat. no. 30
Untitled, 1989, carved wooden clamp, 16 x 23 $^1/_2$ x 2 $^1/_4$ inches
Collection of Martin Melzer

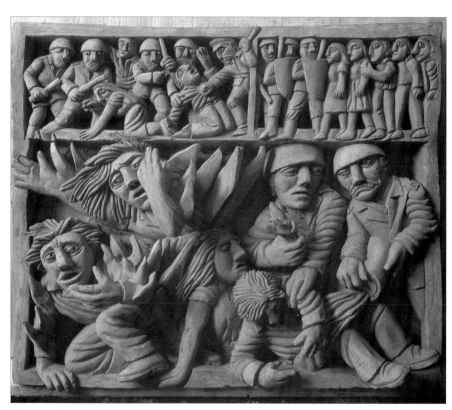

Cat. no. 31
Welcome Home, 1989, terracotta, 16 ¹/₂ x 20 ¹/₂ x 5 inches
Private collection

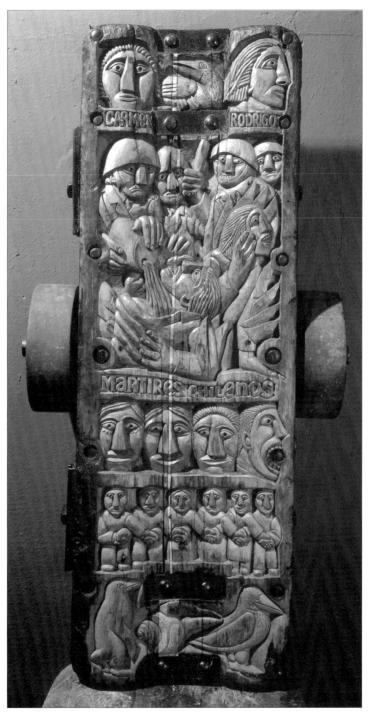

Cat. no. 32
Carmen y Roderigo, 1989, carved wooden and steel dolly
40 x 20 x 8 ¹/₄ inches
Courtesy of the artist

61

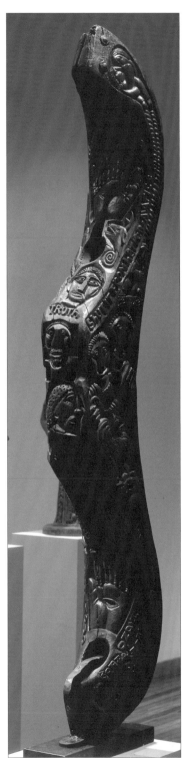
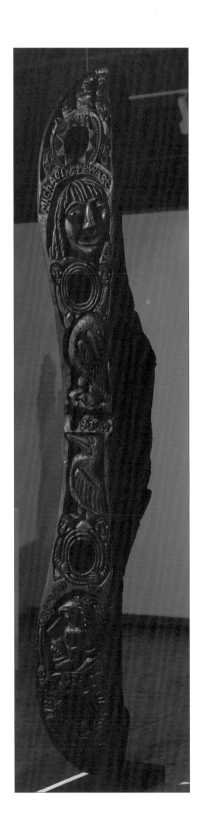

Cat. no. 33
Michael Stewart, 1989, carved
wooden yoke
53 x 7 $^{1}/_{2}$ x 9 inches
Elvehjem Museum of Art
General Endowment Fund
purchase, 1989.58

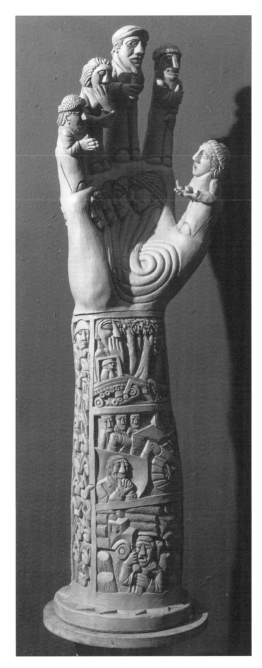

Cat. no. 34
Untitled, 1989, terracotta
H. 46 Diam. 15 inches
Collection of Stephen and Pamela Hootkin
*Not in exhibition

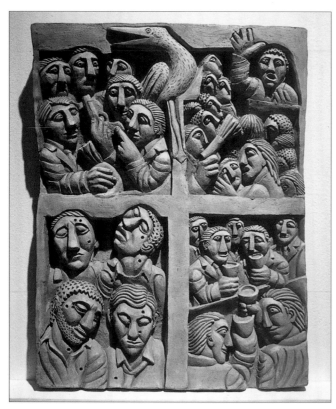

Cat. no. 35
Relief with Bird, 1990, terracotta, 22 x 17 x 2 ³/4 inches
Courtesy of the artist
*Not in exhibition

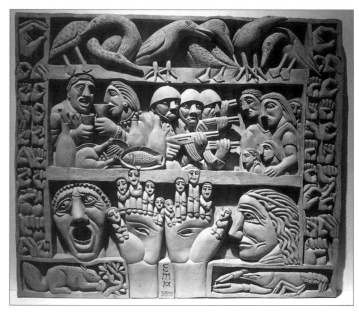

Cat. no. 36
Crawdaddy, 1990, terracotta, 30 x 36 x 2 ³/4 inches
Courtesy of the artist
*Not in exhibition

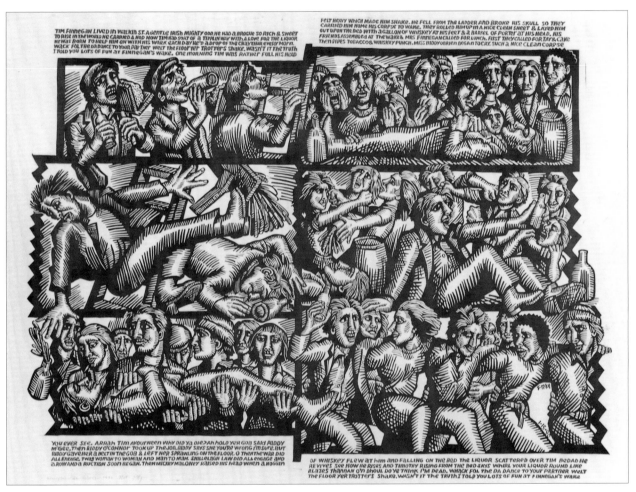

Cat. no. 37
Finnegan's Wake, The Song, 1990, linoleum cut, 35 1/2 x 46 inches (image)
Elvehjem Museum of Art, University of Wisconsin Art Collections Fund purchase, 1991.15

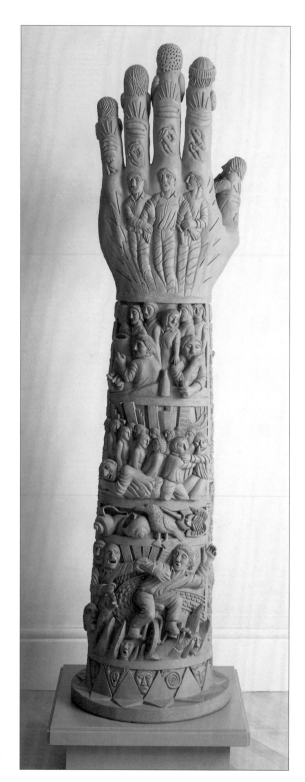

Cat. no. 38
The Artist in New York, 1990–1991
Terracotta, 71 x 19 x 17 inches
Collection of Stephen and Pamela Hootkin

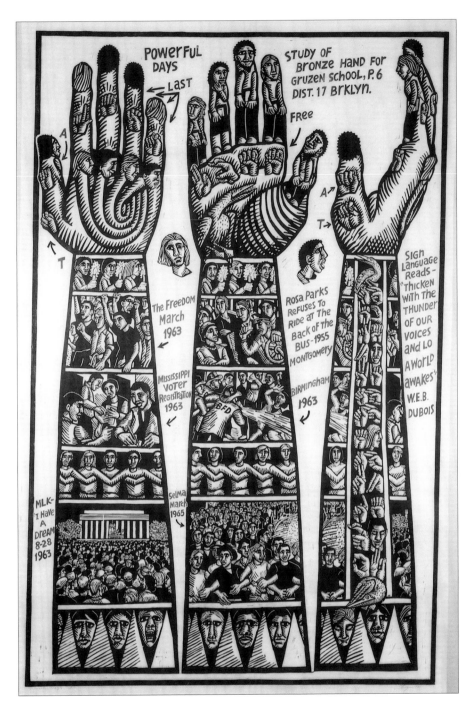

Cat. no. 39
Powerful Days, 1991, linoleum
cut, 70 x 46 inches (image)
Elvehjem Museum of Art, Art
Collections Fund purchase,
2001.53

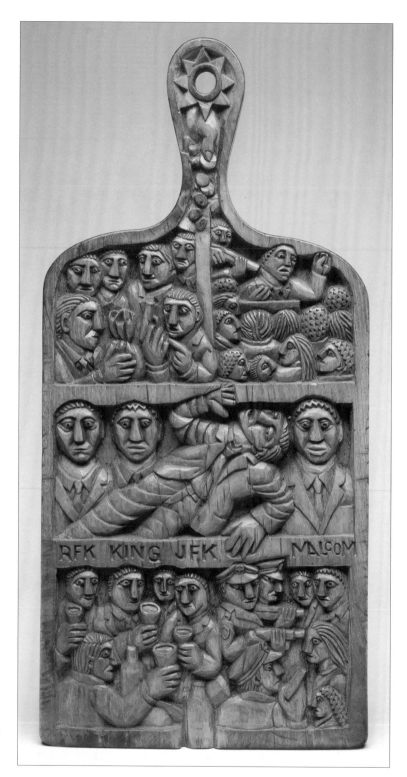

Cat. no. 40
My Ivory, 1991
Carved wooden breadboard
13 ⁷/₈ x 6 ³/₄ x ³/₄ inches
Courtesy of the artist

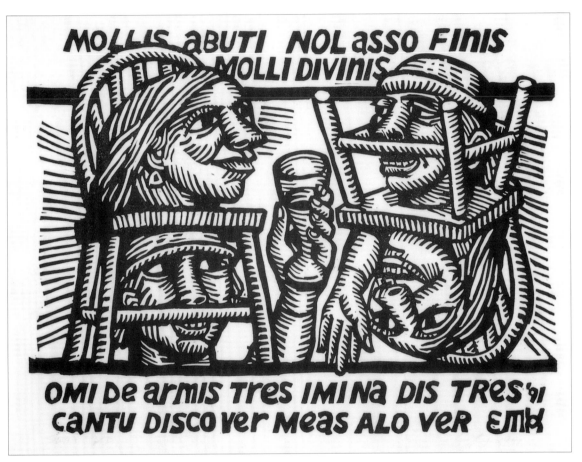

Cat. no. 41
Swift, 1991, linoleum cut, 8 1/4 x 11 inches (image)
Courtesy of the artist

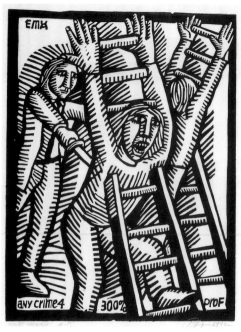

Cat. no. 42
Most Wanted, 1992, linoleum cut
11 x 8 ¹/₂ inches (image)
Courtesy of the artist *Not in exhibition

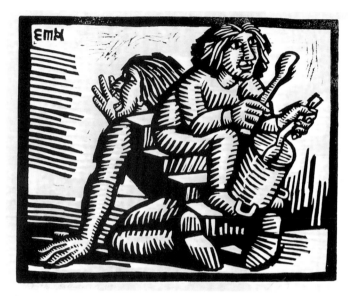

Cat. no. 43
Rhythm Section, 1992, linoleum cut, 8 ¹/₂ x 10 ⁵/₈ inches (image)
Courtesy of the artist

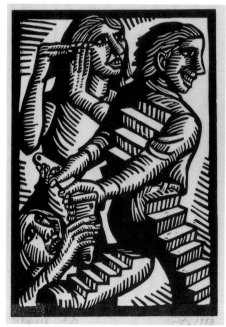

Cat. no. 44
3 Figures, 1993, linoleum cut
9 ¹/₈ x 9 ³/₈ inches (image)
Courtesy of the artist

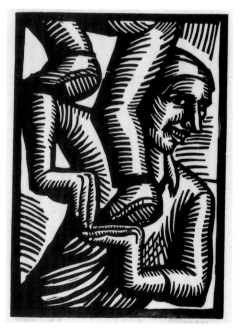

Cat. no. 45
Steps, 2000
Linoleum cut, 9 ¹/₄ x 6 ¹/₂ inches (image)
Courtesy of the artist

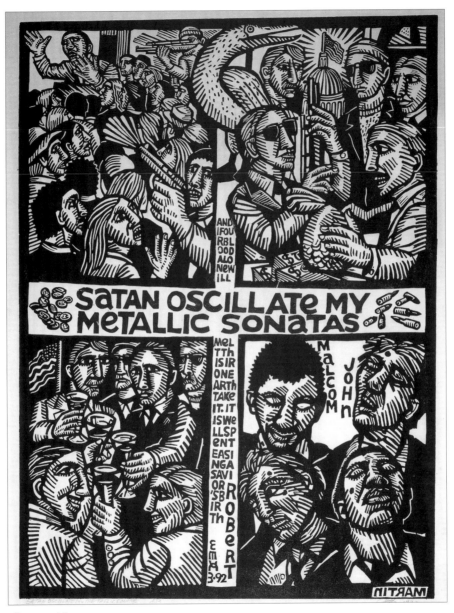

Cat. no. 46
Satan Oscillate My Metallic Sonatas, 1992, linoleum cut, 24 x 17 ⁷/₈ inches (image)
Courtesy of the artist

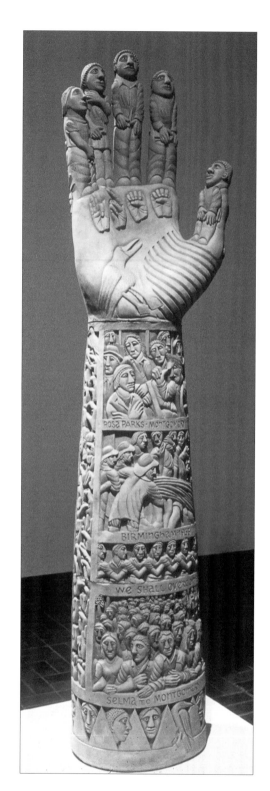

Cat. no. 47
Powerful Days, 1992–1993
Terracotta, 96 x 22 x 17 inches
Courtesy of the artist

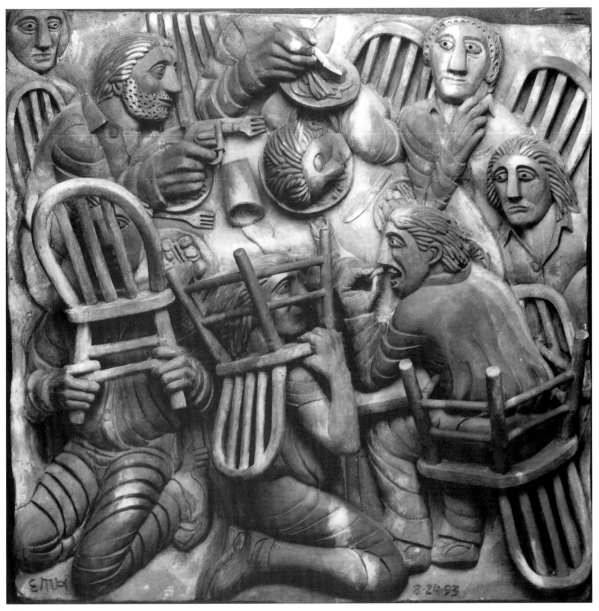

Cat. no. 48
A Last Supper, 1993, terracotta, 36 ¹/₂ x 36 ¹/₂ x 11 inches
Elvehjem Museum of Art, Delphine Fitz Darby Endowment Fund purchase, 2002.1

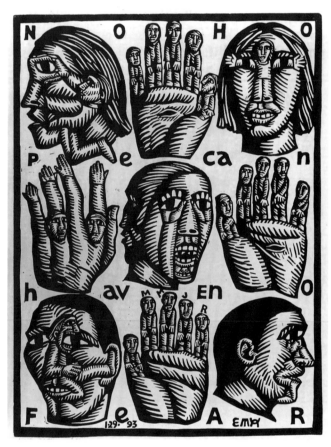

Cat. no. 49
Noho Pecan, 1993, linoleum cut, 18 ¹/₂ x 14 inches (image)
Courtesy of the artist

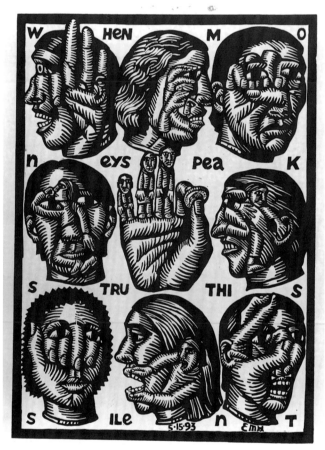

Cat. no. 50
Hen Eys Tru Ile, 1993, linoleum cut, 19 x 14 ¹/₂ inches (image)
Courtesy of the artist

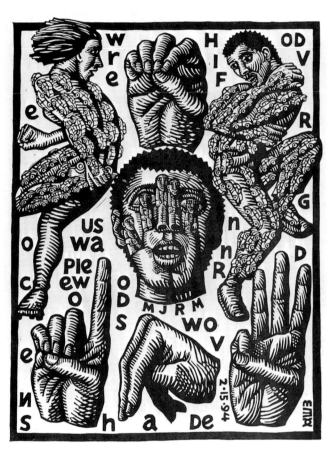

Cat. no. 51
Who Drive Fergus Now, 1993, linoleum cut
20 1/2 x 15 inches (image)
Courtesy of the artist

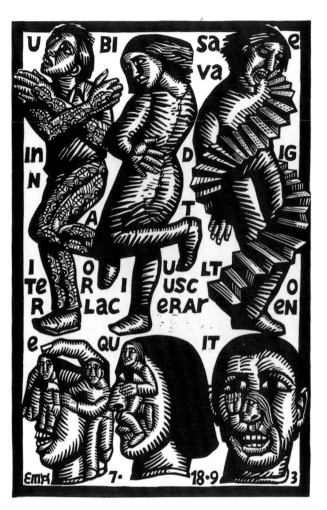

Cat. no. 52
Ubi Saeva—Swift's Epitaph, 1993, linoleum cut
22 5/8 x 15 inches (image)
Courtesy of the artist

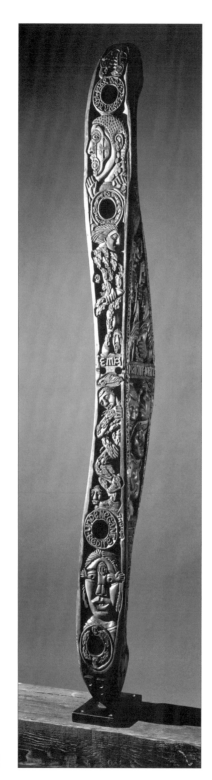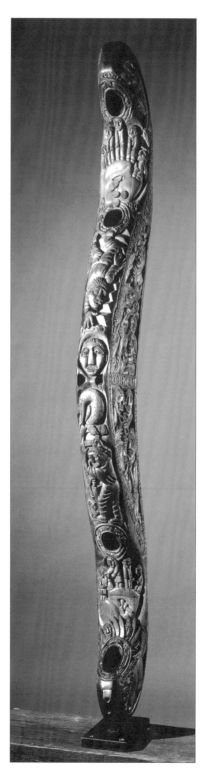

Cat. no. 53
Sculpture for the Blind, dated 7.19.94
Inside face, carved maple yoke, on
black swivel base, 72 x 10 x 6inches
Collection of Monica and Rick Segal

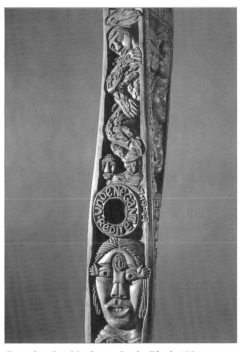

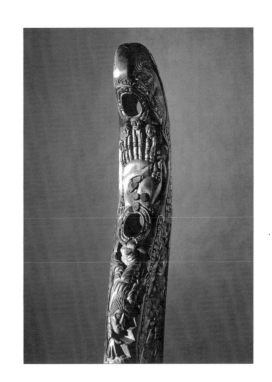

Four details of *Sculpture for the Blind*, 1994

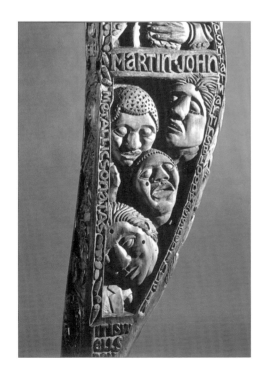

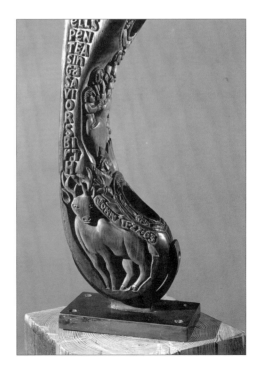

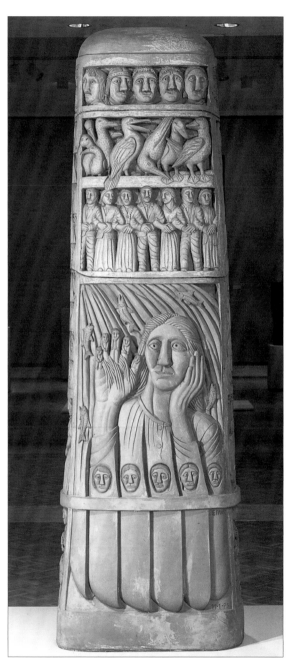

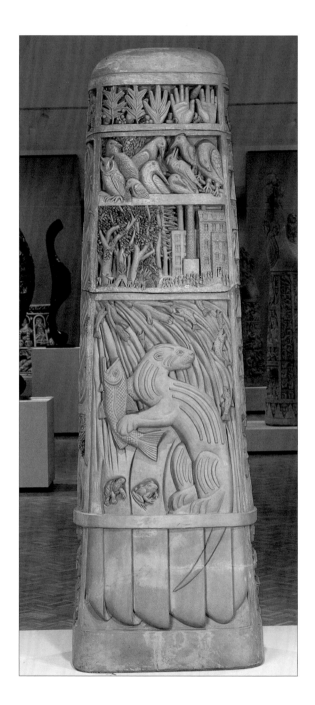

Cat. no. 54
Stele for the Merrimack, 1994–1995, terracotta
96 x 30 x 18 inches
Courtesy of the artist

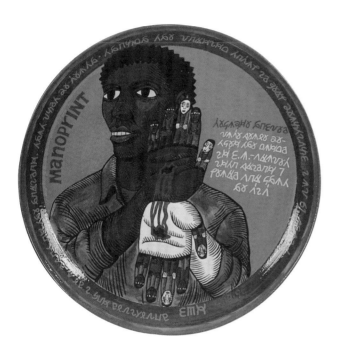

Cat. no. 55
Manoprint, 1996, terracotta with glaze
Diam. 21, D. 2 ¹/₄ inches
Courtesy of the artist

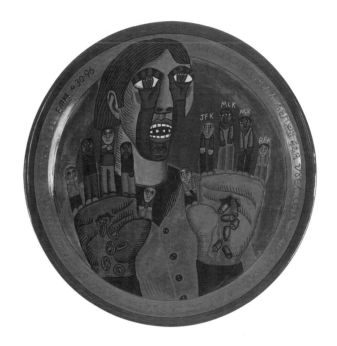

Cat. no. 56
Hands, 1996, terracotta with glaze
Diam: 21, D. 2 ¹/₄ inches
Courtesy of the artist

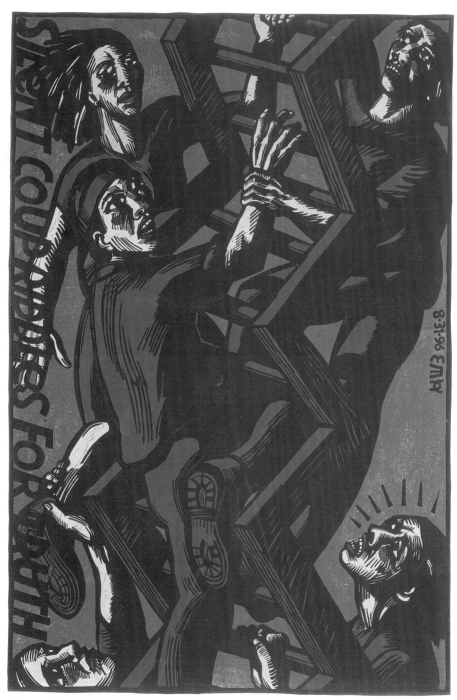

Cat. no. 57
Silent Coup, 1996, color linoleum cut, 52 $\frac{1}{4}$ x 35 $\frac{1}{8}$ inches (image size)
Elvehjem Museum of Art, Delphine Fitz Darby Endowment Fund purchase, 2001.55

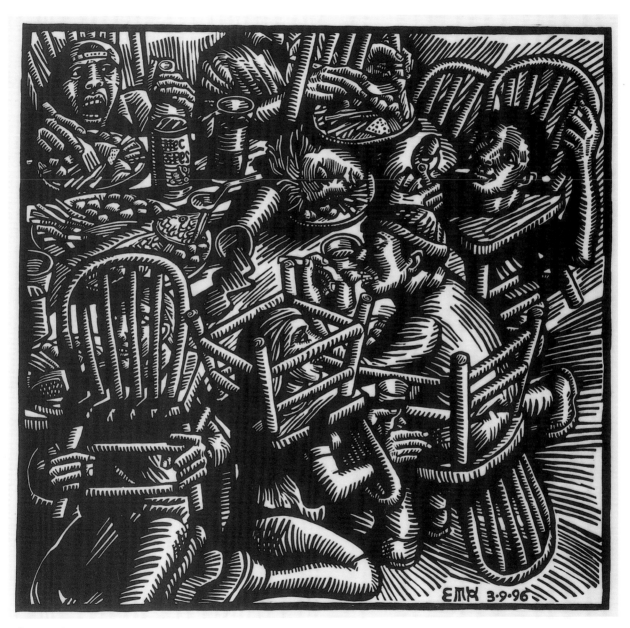

Cat. no. 58
A *Last Supper*, 1996, linoleum cut, 17 ¹/₄ x 18 ¹/₈ inches (image)
Elvehjem Museum of Art, Delphine Fitz Darby Endowment Fund purchase, 2001.54

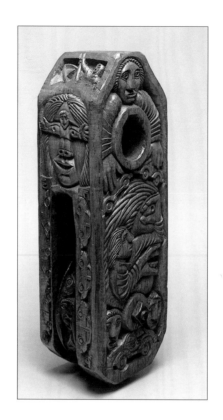

Cat. no. 59
Untitled, 1993, carved
wooden block,
17 x 6 $\frac{1}{2}$ x 4 $\frac{1}{2}$ inches
Courtesy of the artist

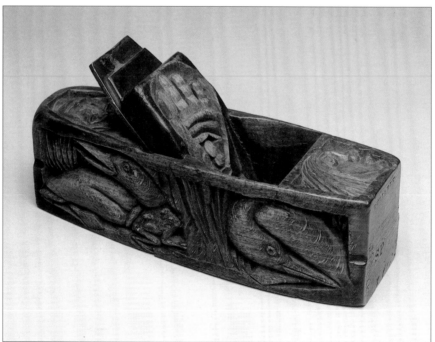

Cat. no. 60
Untitled, 1996, carved wooden carpenter's plane, 4 x 8 x 2 $\frac{3}{4}$ inches
Courtesy of the artist

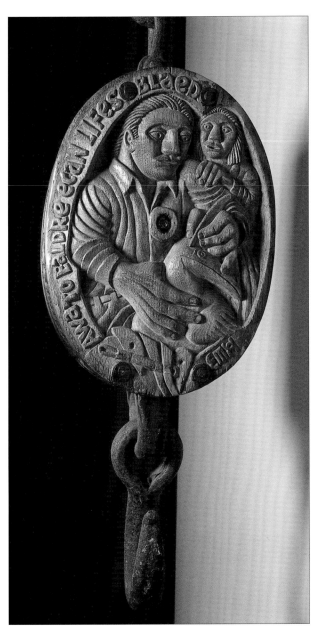
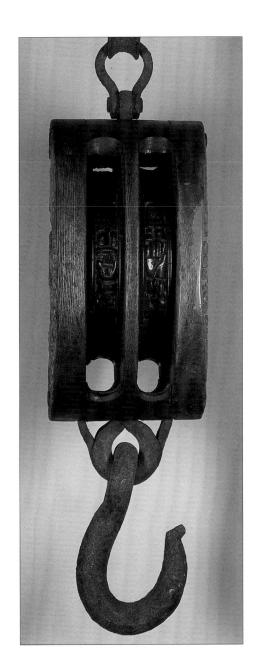

Cat. no. 61
Awa to Ealdre, 1997, carved wooden and steel pulley
27 x 11 x 7 inches
Courtesy of the artist

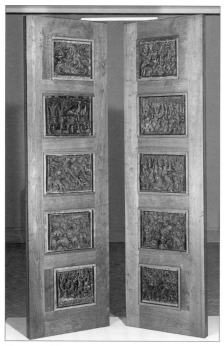
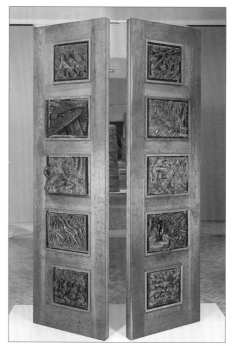

Cat. no. 62
Fate of the Earth Doors, 1997, 20 bronze panels, cherry wood, 114 ¹/₂ x 66 inches, Courtesy of the artist
Seven sets of 24 bronze panels cast to date

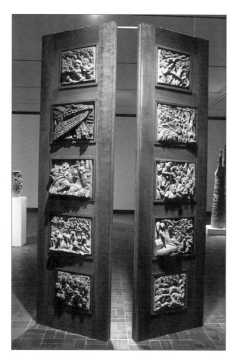
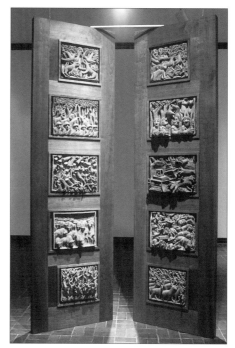

Fate of the Earth Doors, panels in the original terracotta, 1984–1988

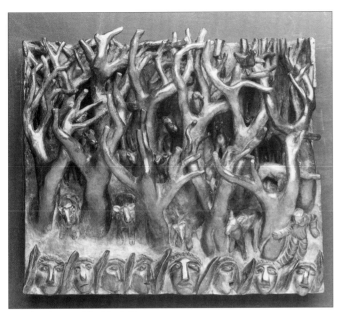
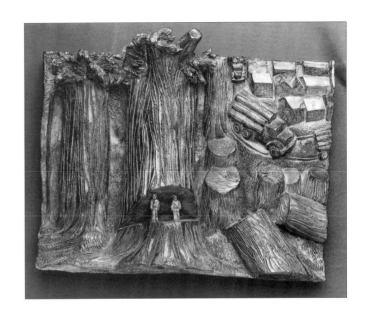

Panels of *Fate of the Earth Doors*

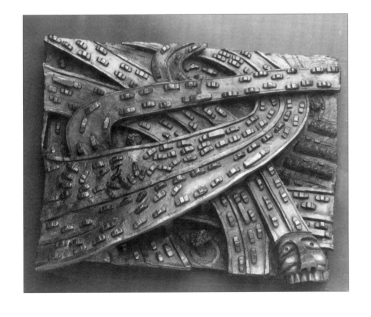
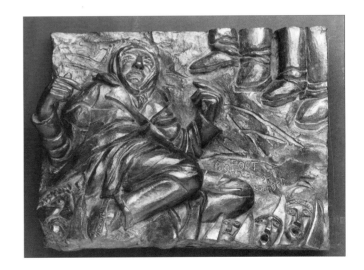

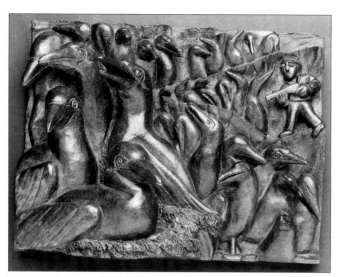

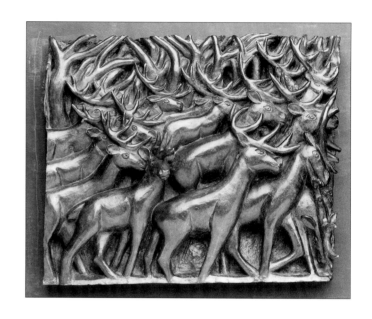

Panels of *Fate of the Earth Doors*

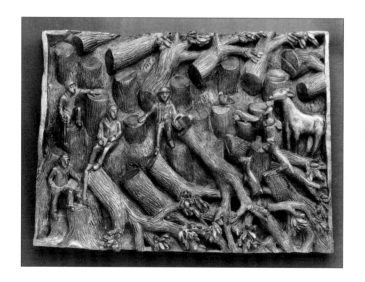

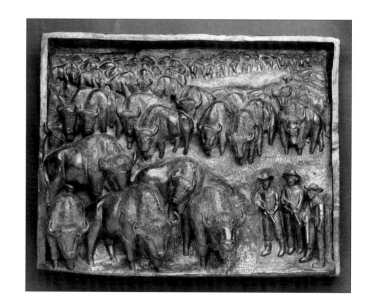

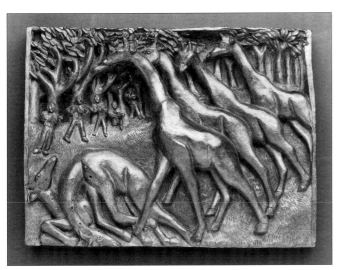

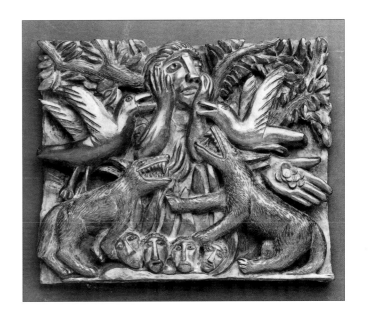

Panels of *Fate of the Earth Doors*

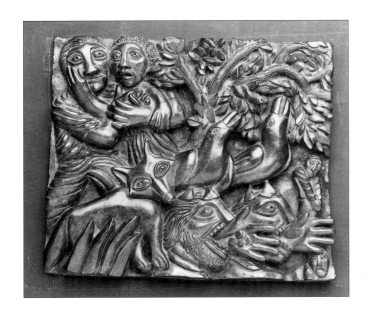

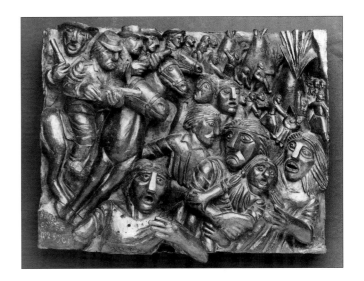

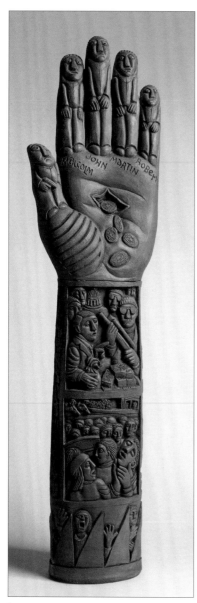

Cat. no. 63
Mamarojo, 1997, terracotta
28 ³/₄ x 7 ¹/₄ x 3 ³/₄ inches
Courtesy of the artist

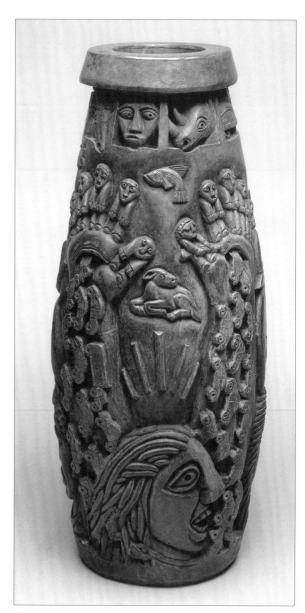

Cat. no. 64
Carmageddon, 1998, bronze, H. 17 ¹/₂, Diam. 7 inches
Courtesy of the artist
Four cast to date

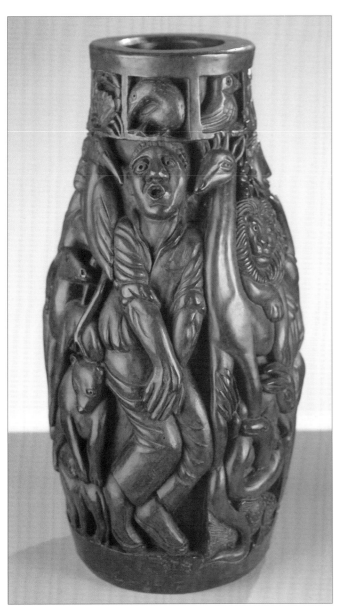

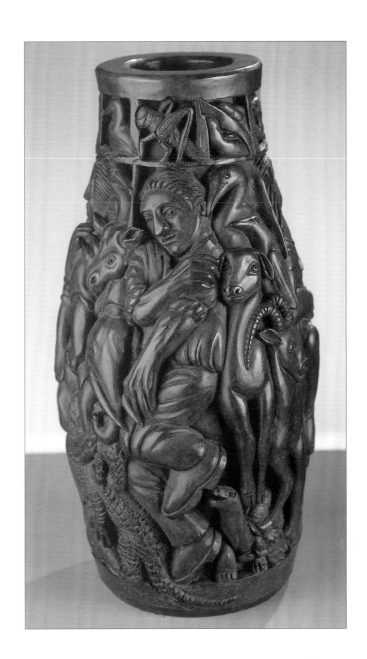

Cat. no. 65
Animal Vessel, 1998, bronze, H. 16, Diam. 8 ¹/₂ inches
Courtesy of the artist
Six cast to date

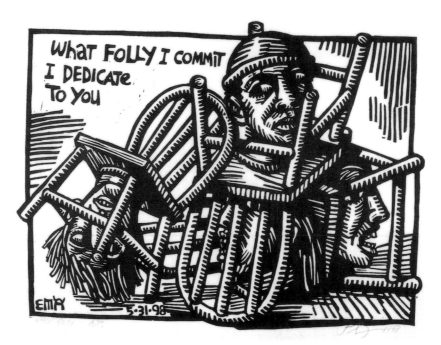

Cat. no. 66
What folly …, 1998, linoleum cut, 7 $^3/_4$ x 10 $^3/_4$ inches (image)
Courtesy of the artist

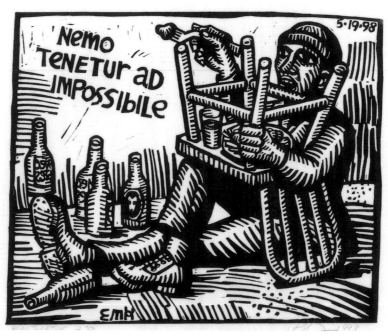

Cat. no. 67
Nemo Tenetur, 1998, linoleum cut, 7 $^3/_4$ x 9 $^1/_4$ inches (image)
Courtesy of the artist

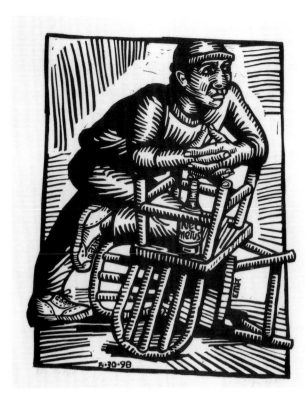

Cat. no. 68
Nec Metus, 1998, linoleum cut
11 x 9 $^1/_4$ inches (image)
Courtesy of the artist

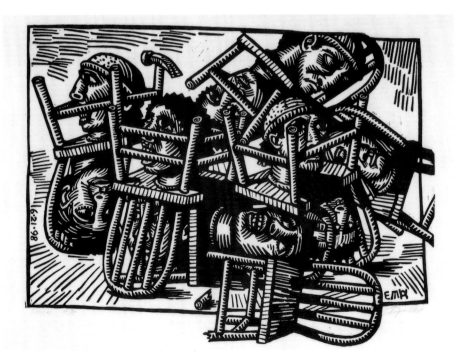

Cat. no. 69
Smoke, 1998, linoleum cut
12 x 16 inches (image)
Courtesy of the artist

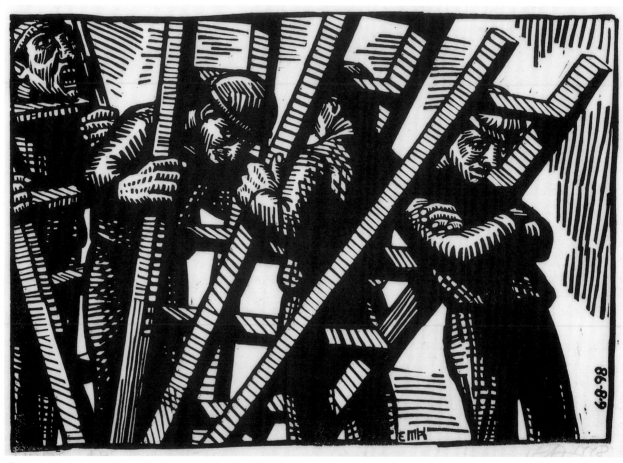

Cat. no. 70
Ladders, 1998, linoleum cut, 9 ¹/₂ x 14 inches (image)
Courtesy of the artist

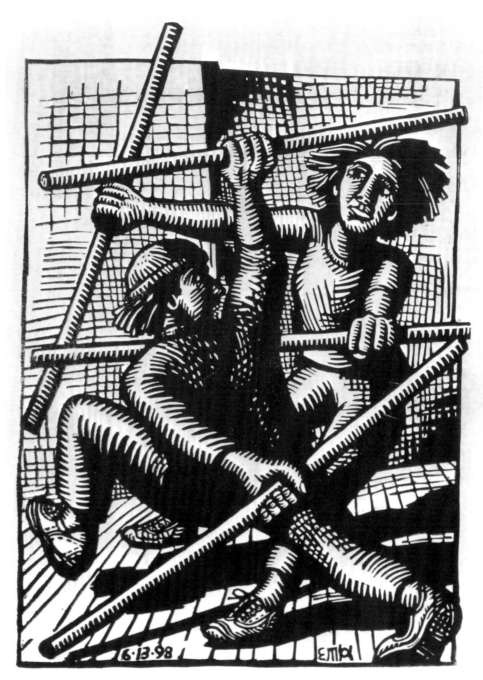

Cat. no. 71
Sketchbook, 1998, linoleum cut, 13 3/4 x 10 inches (image)
Courtesy of the artist

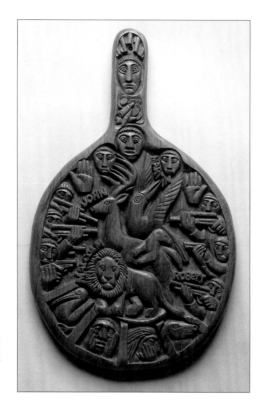

Cat. no. 72
Elizabeth's Breadboard, 1998
Carved wooden breadboard
16 x 10 x 3/4 inches
Courtesy of the artist

Cat. no. 73
Untitled, 1999, carved wooden toolbox, 13 1/2 x 31 1/2 x 7 3/4 inches
Courtesy of the artist

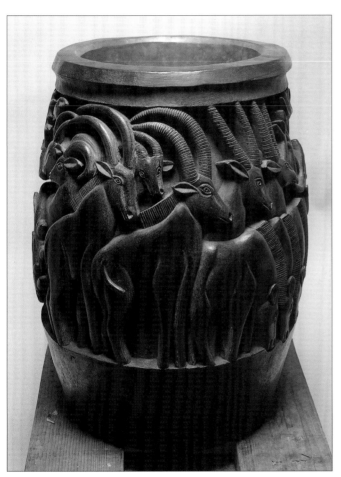

Cat. no. 74
California Urn, 1998, bronze, H. 22, Diam. 16 inches
Courtesy of the artist
Three cast to date

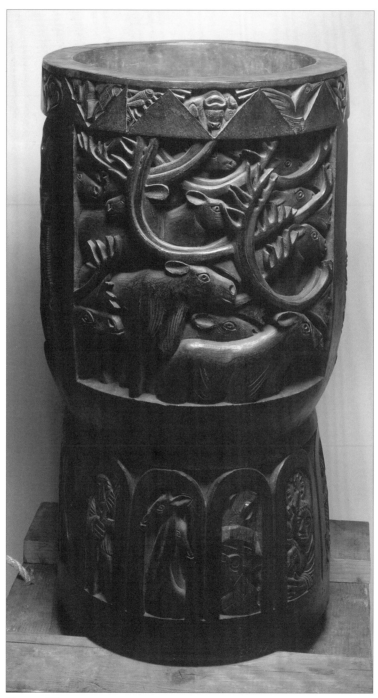

Cat. no. 75
Font, 1999, bronze, H. 33, Diam. 19 ¹/4 inches
Courtesy of the artist
Three cast to date

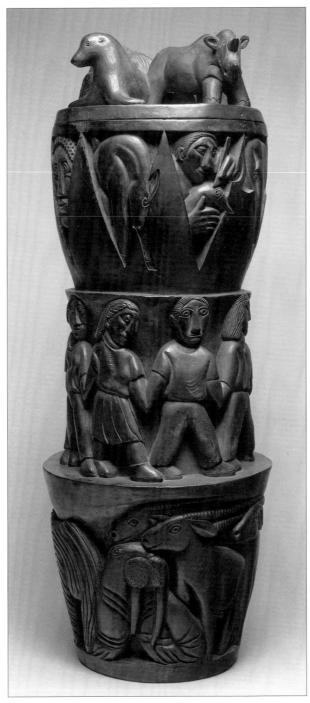

Cat. no. 76
Lidded Vessel, 2000, bronze, H. 26 ¹/₂, Diam. 10 inches
Courtesy of the artist
Three cast to date

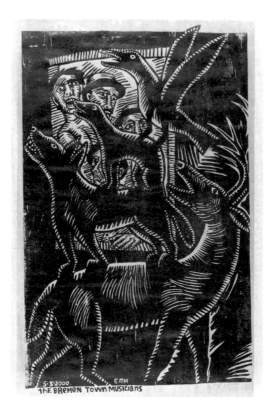

Cat. no. 77
The Bremen Town Musicians
2000, woodcut on brown paper,
24 x 15 ³/4 inches (image)
Courtesy of the artist

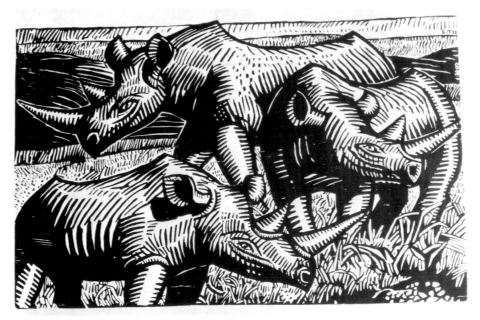

Cat. no. 78
Rhinocerus, 2000, woodcut, 16 x 25 ³/4 inches (image)
Courtesy of the artist

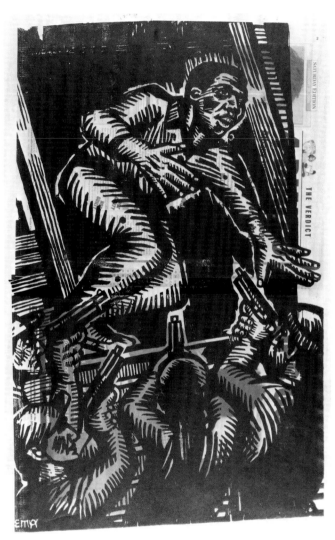

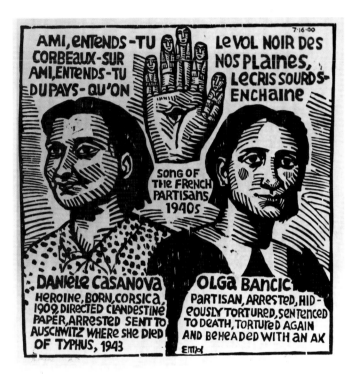

Cat. no. 79
41 Shots, 2000, woodcut on newspaper article in *Daily News*
23 /4 x 14 ³/4 inches (image)
Courtesy of the artist

Cat. no. 80
Partisans, 2000, woodcut, 15 ⁷/8 x 15 ¹/2 inches (image)
Courtesy of the artist

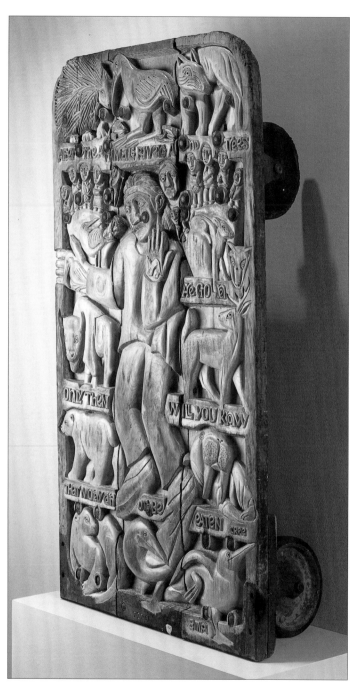

Cat. no. 81
Cree Prophesy, 2001, carved wooden, steel, and rubber dolly
50 x 27 x 12 inches
Courtesy of the artist

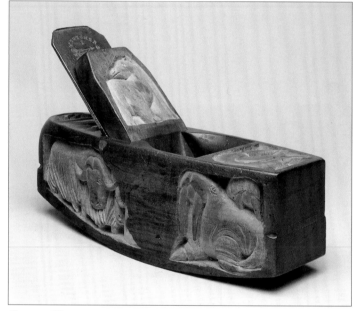

Cat. no. 82
Untitled, 2001, carved wooden carpenter's plane
4 ⁵/₈ x 8 ¹/₈ x 2 ⁵/₈ inches
Courtesy of the artist

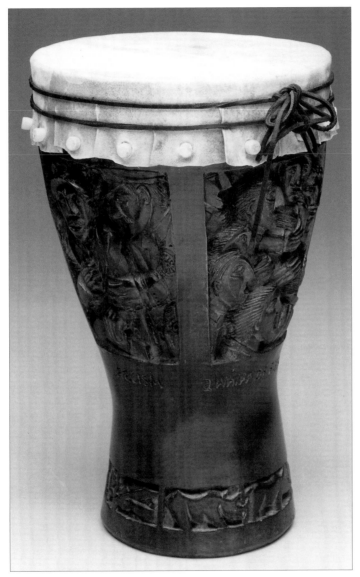

Cat. no. 83
Noon's Prediction (drum), 2001, bronze, rawhide, wooden pegs
H. 13 ³/₄, Diam. 9 inches
Courtesy of the artist
One cast to date

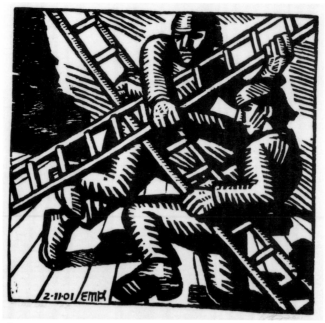

Cat. no. 84
The Fame Game, 2001, woodcut, 13 x 13 ³/₄ inches (image)
Courtesy of the artist

Cat. no. 85
Festival Tizon, 2001, linoleum cut, 8 x 9 ¹/₂ inches (image size)
Courtesy of the artist

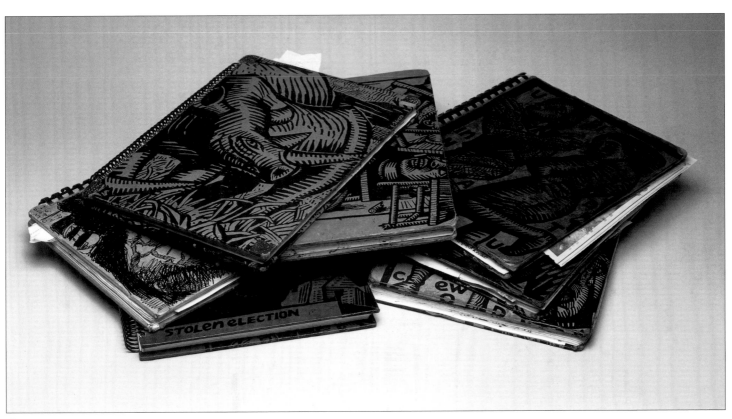

Cat. no. 86
Sketchbooks, 1970s-present, cardboard bound paper, 8 $^1/_2$ x 11 to 9 $^1/_2$ x 12 inches
Courtesy of the artist

Cat. nos. 87–108
From the Sketchbooks, 1968–2001, pen and ink
Courtesy of the artist
*Not in exhibition

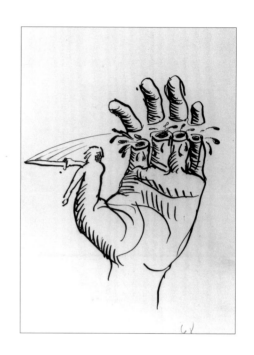

ESCARGOT

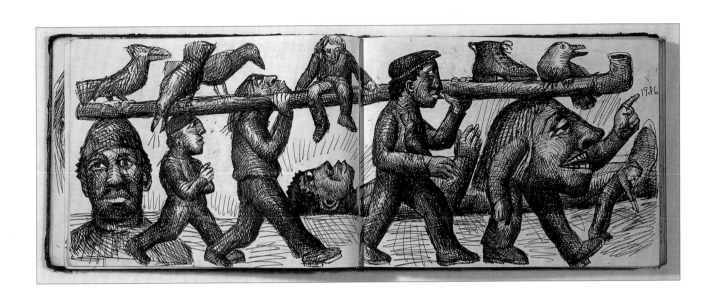

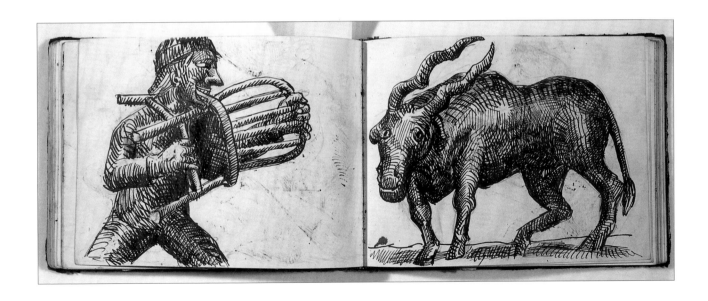

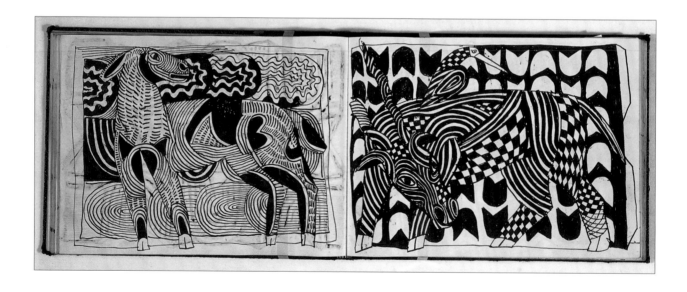

106

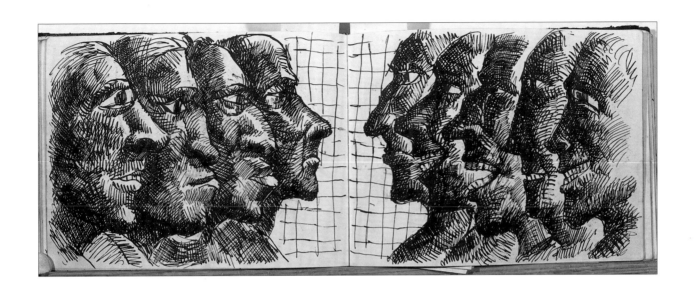

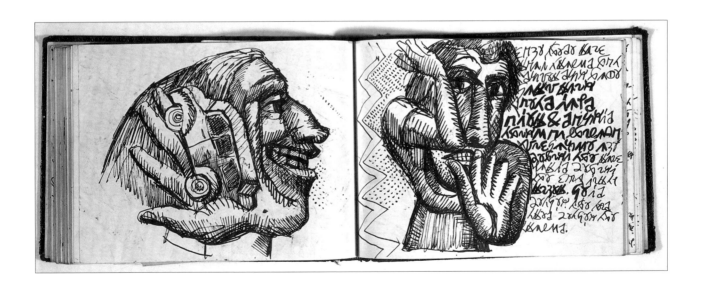

107

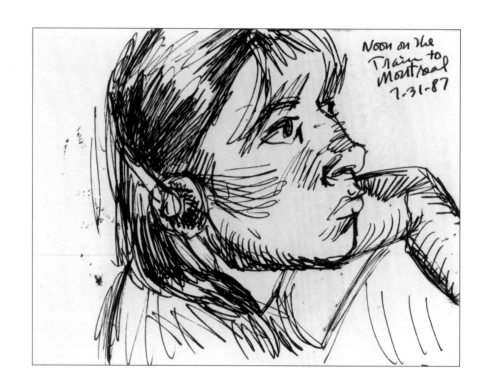

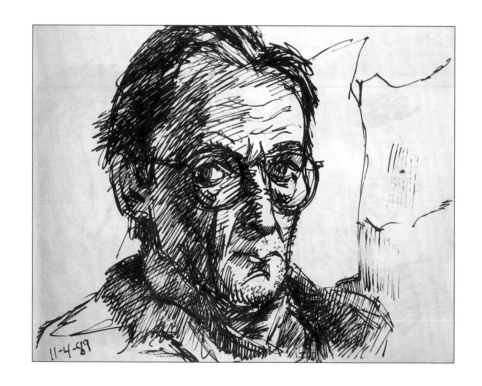

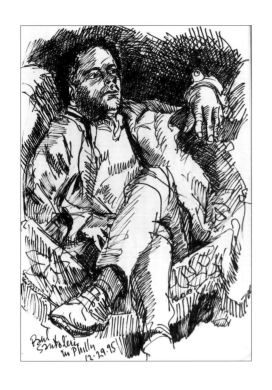

Paul Santoleri
in Philly 12-29-95

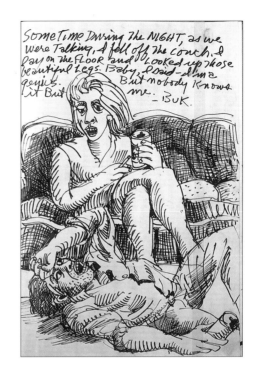

Some Time During the NIGHT, as we
Were Talking, I fell off the couch. I
lay on the FLOOR and Looked up those
beautiful Legs. Baby, Said—I'm a
genius.
 But nobody Knows
it But me. —BUK.

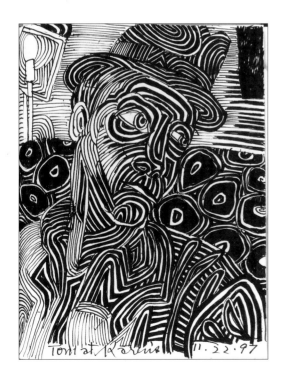

Tom at Karens 11·22·97

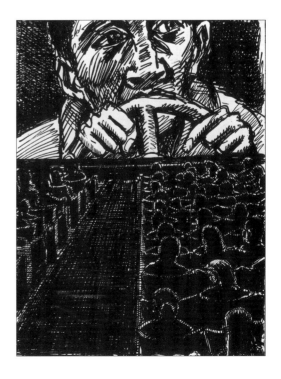

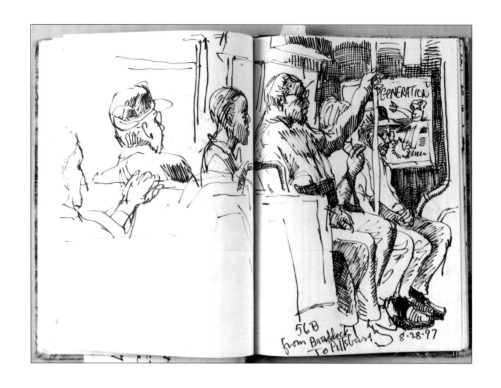

56B
from Braddock
To Pittsburg 8·28·97

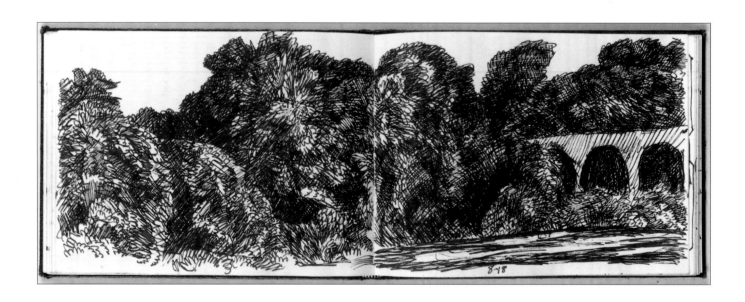

8·18

110

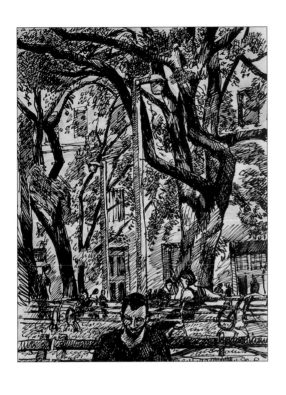

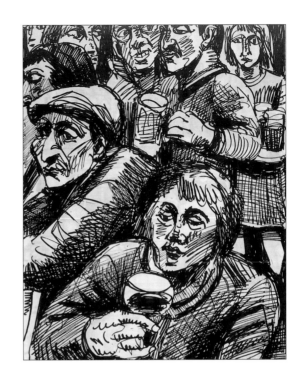

BROOKLYN FROM IN FRONT OF 819 Bedford WTC BURNING - 3:12 AM 9-11-01

Jeanette
in my Doorway
9/11-01 3:30 pm
with the WTC STILL BURNING

Patricia Powell, editor
Earl J. Madden, designer
University Communications
American Printing, printer

Photgraphs by
Chon Y Lai—color plate 8
Russell Panczenko—pp. 42–43
Bob Rashid—color plate 12, cat. no 61
Jim Wildeman—color plate 2; cat. nos. 1, 2, 4, 11–13, 24,
30, 54, 57, 62, 65–71, 74, 77–81, 83, 84, 87–108